D0792923

Visions Underground

Carlsbad Caverns Through the Artist's Eye

Lois Manno

© 2009 by Lois Manno

All rights reserved. Rio Grande Books, an imprint of LPD Press
Printed in Canada
Book design by Paul Rhetts

No part of this book may be reproduced or transmitted in any form, or by any means, electronic or mechanical, including photocopying, recording, or by any information retrieval system, without the permission of the publisher.

Library of Congress Cataloging-in-Publication Data

Manno, Lois (Lois S.)
Visions underground : Carlsbad Caverns through the artist's eye / Lois Manno.
p. cm.
Includes index.
ISBN-13: 978-1-890689-95-7 (pbk.)
ISBN-10: 1-890689-95-5 (pbk.)
1. Carlsbad Caverns (N.M.)--In art. 2. Carlsbad Caverns (N.M.)--Pictorial works.
I. Title. II. Title: Carlsbad Caverns through the artist's eye.
N8214.5.U6M29 2009
704.9'43678942--dc22
2009008408

Published by Rio Grande Books/www.nmsantos.com in collaboration with
The National Speleological Society/www.caves.org

Front cover: *WPA Silkscreen print by Alexander Dux, circa 1939, 28" x 22". This print was used to create the "See America" travel poster.* Back cover: Ansel Adams, *1936, by John Charles Woods and* The Big Room, *1936, by Ansel Adams.*

Visions Underground

Carlsbad Caverns Through the Artist's Eye

Lois Manno

published by Rio Grande Books
in collaboration with The National Speleological Society

Our time is short, and the future terrifyingly long. Believing as we must that things of the heart and mind are most enduring, this is the opportunity to apply art as a potent instrument of revelation, expression, and perpetuation of wilderness activities and moods. Through art of brush, pen, and lens, each one no less than another, we possess a swift and sure means of touching the conscience and clearing the vision.

Ansel Adams

Acknowledgements

My thanks and appreciation goes out to the staff at Carlsbad Caverns National Park, especially Marie Marek, who shepherded my art project through numerous snags, Dave Kayser for sharing his knowledge of the park's collections, and Superintendent John Benjamin for his vision and support. People like retired NPS historian Bob Hoff and Carlsbad Museum Director Virginia Dodier clued me in to interesting tidbits that I probably would never have stumbled on myself. A special thanks goes to Tom Rea of The National Speleological Society for his support of this project. T.K. Kajiki and the board of the Carlsbad Caverns Guadalupe Mountains Association supported the exhibit from its inception, and Jamie Hascall of the Museum of New Mexico made sure everything was hung straight and lit correctly. What a lifesaver!

I'm grateful to the artists who generously contributed images to both the exhibit and the book; such an outpouring of enthusiasm made the work a joy. Many of my caver friends also contributed to the book and helped me stay sane, like Bill and Georganne Payne, Michael Queen, Peter Jones, Tim Kohtz, Dale Pate, and Tim Boyd, to name a few. My editor and dear friend Dave DeWitt believed in me and made this book possible, and my publishers Paul Rhetts and Barbe Awalt graciously put up with all the delays and changes I made in my quest for the "perfect" book. My wonderful husband Jack cooked and cleaned while I lived on my computer, and drove hundreds of miles back and forth between Santa Fe and the Caverns during my research trips without complaint. Finally, thanks to my daughters Kelli and Sara Bergthold for constantly telling me how "cool" it was that I was writing this book—that made it all worthwhile.

A New Definition of Cave Art

I have worked with Lois Manno for more than twenty years so I've known about her love of caves and caving for quite a while. In fact, over the years I've sent her many clippings and Internet articles about unusual cave features around the world and have encouraged her to find a fascinating cave topic and write a book. And she finally did it!

Her topic is totally unique in cave literature because when we use the term "cave art," it conjures up Cro-Magnon artists in Europe 30,000 years ago painting cave walls with iconic images of now-extinct animals. About 350 known caves worldwide have mostly Paleolithic images on their walls. The prehistoric artwork, as stunning as it appears, is an example of mankind using a cavern wall as a mineral canvas for artistic expression—unheard of in these days of keeping caves totally pristine.

But Lois wondered, *What if nature made the art and human beings merely recorded it and interpreted it? Would that be cave art as well?* As this book proves, indeed it *is* cave art.

And what better person to document the cave art of Carlsbad Caverns than a caver who is also an artist? Or, rather, *two* artists because Lois not only is a commercial graphic artist who designed two magazines I edited, but she is also a fine artist in several media. Some of her cave studies are reproduced in this book and

so Lois, as author and artist, becomes a part of cave art history, too.

Caves inspire awe, curiosity, and fear. Perhaps because they were used as havens and sacred sites during the evolution of mankind, caves continue to fascinate us with their dark promise of adventure. As psychological archetypes, they touch humanity's deepest, most primal emotional core. Since the discovery of Carlsbad Caverns in New Mexico in the late 1800s, adventurers, photographers, writers, and artists have explored its depths, seeking to capture the elusive beauty that fills its enormous chambers and intimate grottos. Sadly, the average visitor is unaware of the cultural and historic treasures associated with the Caverns, because they have never before been made available for viewing in a cohesive manner.

Lois has volunteered at Carlsbad Caverns for more than fifteen years. The National Park Service completed its renovation of the existing visitor's center in 2008 and a new exhibit featuring works of fine art and photography from the park's collection was placed on display, many items for the first time. Lois worked for a year and a half with National Park Service managers as primary curator for this exhibit.

Her volunteer efforts produced *Visions Underground,* which weaves together the work of historic and contemporary artists from various

disciplines to create a portrait of Carlsbad Caverns National Park as inspiration and muse. This book explores the integral part the arts have played in the development and preservation of the national parks generally, and Carlsbad in particular. Part exhibit catalog and part history of exploration, Lois' book follows the tracks left by creative people as they encountered the cave, beginning with prehistoric pictographs in the cavern entrance. The path leads through the courageous artist-explorers of the 1920s like painter Will Shuster and photographer Ray V. Davis, and onward to document Ansel Adams' struggle with photographing in the inhospitable darkness. At one point during his work at the Caverns, Ansel Adams wrote a letter to friend and fellow photographer Alfred Stieglitz, asking him to "pray for me." In the process of recording the history of artists at the park, *Visions Underground* describes a one hundred-year continuum of how the subterranean world has been portrayed in various media, from before the turn of the century, through modern times.

Many lovers of artistic expression will be impressed by the highly dramatic paintings of the larger features of the Caverns, such as Will Shuster's "Carlsbad—Multi-Color" and Raymond Jonson's monumental triptych "Cavern Trilogy" (1928), which resides at the Albuquerque Museum. I love them too, but I'm also drawn to the spectacular photography of what might be termed cave minutia, such as "Cave Pearl, Guadalupe Room" by Kevin Glover and "Oasis Helictite," by Peter and Ann Bosted. These photos—almost microphotographs—are very surreal and so "extra-terrestrial" in appearance that they might have been shot on the moon Titan. But they weren't. They are intra-terrestrial, a product of time, chemistry, and natural change. We often think of caves as static, as if they are frozen in time. But they aren't—they are constantly changing, albeit very slowly. Caves are subject to many of the same forces that change the above-ground world, like erosion, flooding, earthquakes, fires (very rarely), and human impact. Works of art like the ones featured in this book document the state of a cave at a specific moment in time, while also serving as a means of artistic expression.

And speaking of preservation, Lois has provided valuable support to the National Park Service and to photographic art history by featuring "lost" original photographs of the Caverns by Ansel Adams, perhaps America's premier photographic artist. Twenty-five original Adams prints disappeared from park records for forty years, finally resurfacing in an unlocked storage cabinet at the park around 1978. They have been in secure storage since then, and the prints have been placed on display for the first time since they were rediscovered as part of the new exhibit.

Creative people still flock to Carlsbad Caverns, which was designated a World Heritage

Site in 1995. Examples of their work, visual as well as literary, are all a part of the book's scope. In addition to Ansel Adams' struggles to photograph the cave, Will Rogers wrote expansively about Carlsbad Caverns, and internationally known Japanese-American woodblock artist Toshi Yoshida created a print entitled "Carlsbad Caverns" in 1954. The cast of characters is as diverse as American culture itself.

Of course, it is physically impossible for the art lover to view all of these images in person because of the public's very limited access to all parts of the approximately 32 miles of surveyed cavern passages. But at least with this volume we can visually experience the new definition of cave art.

Dave DeWitt
Award-winning author of
Cuisines of the Southwest
and *Avenging Victorio*

Foreword

As with most really interesting projects, the Cavern Arts Project began with a mystery. While staying at Carlsbad Caverns National Park during one of my frequent caving trips there around 1994 (I work as a volunteer and spend several weekends a year at the Caverns), I found myself discussing photography with a photographer/caver/geologist friend of mine, J. Michael Queen, Ph.D. During our chat, he mentioned that Ansel Adams had taken several shots of the cave back in the 1930s. I was fascinated by this, as I had not seen any cave photographs by Ansel Adams. Michael went on to say that these photographs had been "discovered" in an old metal cabinet in the park Superintendent's office "sometime around 1975" by Ron Kerbo, who was a manager at the park and eventually became the National Park Service's National Cave Specialist.

I asked what happened to the photos. Michael said he wasn't sure, but he thought they might have been put on display one time and then sent to storage somewhere. That set me on a quest to find Ansel Adams' photographs and see if they could be exhibited at the park. With the assistance of art historian/caver Kevin Justus, I learned that the prints were in storage at an archival facility in Tucson that houses items for parks that don't have proper facilities on-site. I shared this exciting news with managers at Carlsbad Caverns, who were not aware that they had a collection of twenty-five signed Adams prints waiting to be exhibited!

At that point I decided to make a proposal to the National Park Service to raise funds and gather together professional resources adequate to mount an exhibit of fine art and photography at the Caverns. I was surprised to learn that the park was just about to break ground on a rehabilitation of the outdated visitor center facilities, including completely revamping the park's exhibits. Not only did I have permission to mount an exhibit, but John Benjamin, Superintendent at Carlsbad Caverns, had decided to dedicate several hundred square feet to create a permanent museum-quality gallery space for the park's collection of paintings, prints, and photographs. The National Speleological Society came on board as a sponsor of the exhibit as well as a companion book. Suddenly the Cavern Arts Project took on a life of its own, and I was along for the ride.

About two years later, on October 25, 2008, Carlsbad Caverns National Park celebrated the opening of the new visitor center. The permanent exhibit space was finished, and over fifty pieces of art and photography from the park's collection were on exhibit, including four of the original Adams prints that had been conserved and archivally framed. It was a proud

moment for me, for park managers, and for all the artists who had donated work to the park's collection over the years.

During the research required for the exhibit (and later, for this book), I learned about Will Shuster—the first artist to paint the cave before it was a national park, and Mercedes Erixon—the first *woman* artist to portray the cave. I learned about many other "firsts" that occurred at the park: the world's first subterranean daguerreotype; the world's first color underground photograph; the world's largest (at the time) photographic print; the photo-graph with the largest number of flash bulbs ever made, and the list went on. To my publisher's chagrin, even during the last weeks of fine-tuning the manuscript I kept discovering new and incredible information that just "had to be in the book," like the 1933 photograph of a full symphony orchestra about to perform Haydn's "Creation" Oratorio in the Underground Lunchroom. I'm sure there are more treasures that haven't come to light, so some future enthusiast will have the pleasure of solving more of the art mysteries at Carlsbad Caverns National Park.

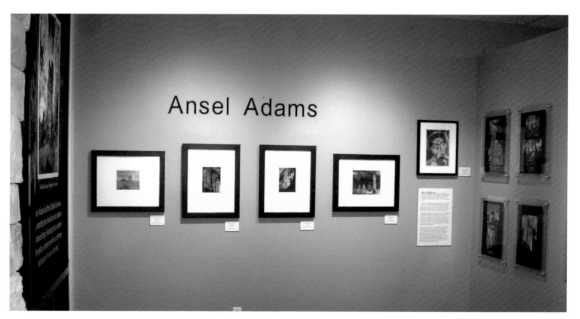

The Ansel Adams section of the gallery in the Carlsbad Caverns National Park Visitor Center. Four original prints are on exhibit, and they will be changed out regularly so that all twenty-five prints will eventually be shown. The wall on the right contains reproductions of the other Adams prints in the collection. Photograph by Lois Manno.

Contents

Chapter One
The Artist-Explorers

At first glance, New Mexico's Eddy County is the last place one would expect to find a national park. Tucked into the state's far southeast corner, the landscape is minimalist and severe. This northernmost lobe of the vast Chihua- huan desert bares its tough, limestone-crusted hide to the casual viewer, a surface made even more hostile by decades of overgrazing and nat- ural gas exploration. Tangles of mesquite share the depleted range with spiny clumps of agave

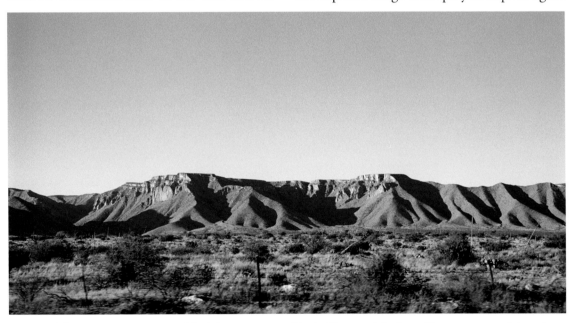

The Guadalupe Escarpment near Carlsbad Caverns National Park. Photograph by Bryan Turner, courtesy of the artist.

and prickly pear cactus. The mostly flat terrain is dotted with natural gas wells, drill rigs and standpipes, and has been sliced into a patchwork by lease roads. The only hint that there might be something more to this place exists in the form of a thousand-foot-high escarpment that stretches unbroken for over thirty miles, from the Texas state line in the southwest to the northeast near the town of Carlsbad. It's little wonder that few artists from northern New Mexico's thriving art colonies ever ventured so far south during the early part of the last century.

But a hardy few did come, enduring several days of travel across the decidedly monotonous gypsum plains near Roswell, south into ever more arid terrain. They were drawn by rumors of a strange, wonderful place hidden deep in the hills near the small town of Carlsbad. Indeed, the artists who visited this area were rewarded with abundant inspiration—they merely had to look below the surface to find it.

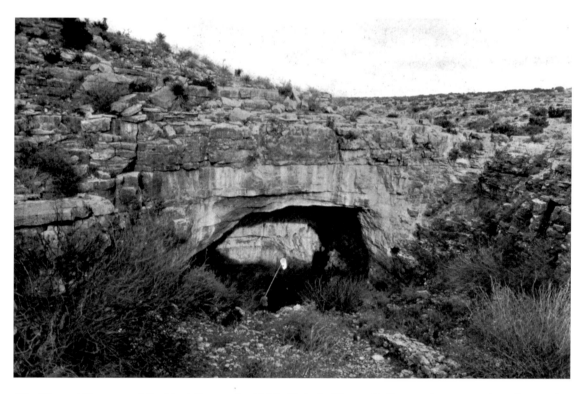

The Natural Entrance of Carlsbad Caverns in 1925. Biologist Vernon Bailey can be seen catching bats with a net. Photo by Willis T. Lee, courtesy of Carlsbad Caverns National Park.

Artistic Vision—The Foundation of the National Park System

One artist who recognized the broad appeal of a wondrous and mystifying subject was Thomas Moran. In 1871 he had accompanied the Hayden survey to Yellowstone, creating magnificent watercolors of its shooting geysers and boiling hot springs, so vivid and widely promoted that in 1872 they prompted Congress to designate Yellowstone as the country's first national park.[1]

Thomas Moran (1837-1926) was instrumental in helping promote the establishment of national parks and monuments across the country. By the time he died, he had painted a dozen areas that would become part of the National Park System. His paintings and field sketches brought to life the spectacular geology of the West in a way that fueled the nation's desire to gain a cultural identity through the preservation of its monumental scenery. The work of artists like Moran and Albert Bierstadt gave a taste of majesty to the vast majority of Ameri-

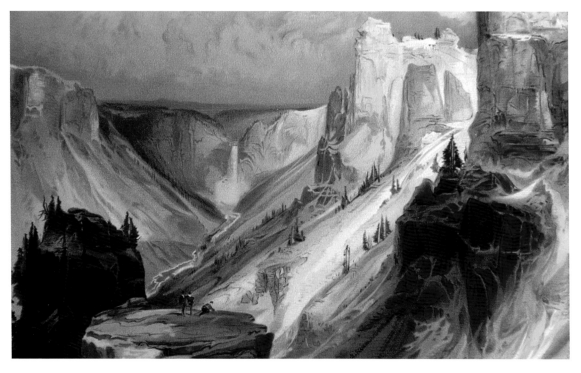

Grand Canyon of the Yellowstone, *1872 by Thomas Moran. Moran painted numerous watercolor studies like this one, in addition to larger oil paintings. NPS photo.*

cans who would never be able to see firsthand the wonders of the West. [2]

Unlike the "Crown Jewel Parks"—Yellowstone, Yosemite, and the Grand Canyon—glorified on canvas by men like Moran, Carlsbad Caverns did not display the almost unseemly abundance of beautiful vistas and dramatic peaks that compelled artists and photographers to travel across the country in droves. Indeed, it is difficult to imagine a park with more lowly origins: Carlsbad was for many years viewed as little more than an underground chamber from which the fecal material generated by a vast colony of Mexican freetail bats was mined for fertilizer.

"In Search of Something That Might Turn Out To Be Valuable"

Around 1900, life in southeastern New Mexico was hardscrabble at best. Residents had to be resourceful in order to survive.[3] One such

Artist's Conception of Long's Move to Big Cave Area. By Gossie Koller, from The Big Cave *by Abijah Long and Joe N. Long.*

individual was Abijah Long, a jack-of-all-trades who arrived in the area via covered wagon with his family in 1901. One day in 1903, while he and some friends explored the area "in search of something that might turn out to be valuable," he encountered a small cave entrance, then a much larger one nearby. They dropped a rope ladder into the pit and began exploring with torches. Eventually they wandered into a chamber filled nearly to the ceiling with bat guano, some deposits nearly one hundred feet thick. Long returned to Carlsbad and immediately filed a mining claim on the cave. [4]

As is the case with many grand tales of the West, there exist multiple accounts as to who was the first to officially "discover" what was, at the time, simply known as The Bat Cave. James Larkin White figured prominently in the early development of the cave and in his dictated autobiography, claimed to be the discoverer of Carlsbad Caverns in June of 1901.[5] However, a signature scratched into a boulder far into the "dark zone" of the cave reads "J White, 1898" and is believed to be authentic.[6] According to his account, the sixteen-year-old White was riding across the range and was drawn to the entrance by the sight of a black cloud that rose from the ground in a tall column. This cloud turned out to be the evening flight of millions of bats that roosted in the cavern by day.

It is doubtful whether these disputed dates and claims will ever be resolved, and it is obvious in comparing the two men's accounts that

certain resentments festered beneath the surface: according to White's book, he was hired to be the first foreman of the guano mining company in 1902, but he never mentioned Abijah Long by name. Similarly, there is absolutely no mention of Jim White at all in Long's memoir.

What cannot be overstated is the extent of Jim White's love of the caverns and his commitment to share its wonders with anyone who would listen. He explored the cave further than anyone else at the time, and often brought visitors with him. At his expense and with his own manpower, White spent countless hours in the darkness, building trails.

In 1922 White took local photographer Ray V. Davis into the cave, and a powerful promotional team was born. Through their joint

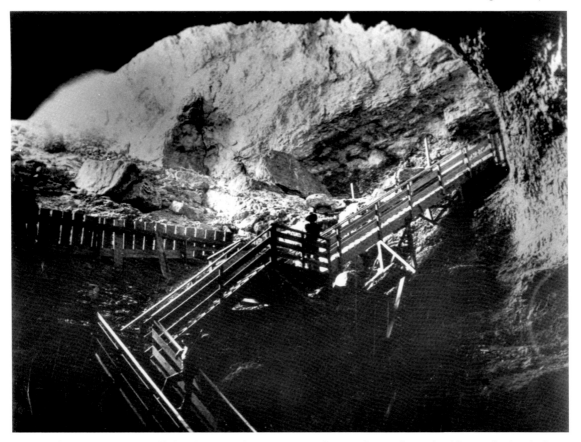

This wooden stairway was installed in the Natural Entrance around 1925, thus rendering the old guano bucket obsolete as a means of visitor transport. NPS photo by Ray V. Davis.

efforts, the visual wonders of The Bat Cave came to the attention of two powerful individuals: Stephen T. Mather, the first director of the recently formed National Park Service, and his assistant, Horace M. Albright. With what would be considered by today's standards

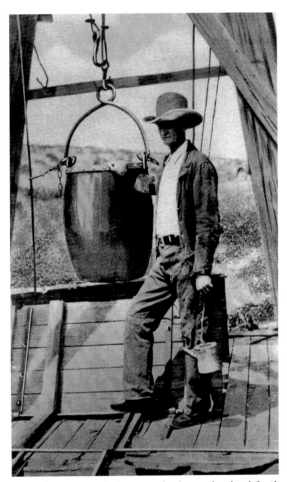

Jim White poses with the guano bucket used to haul fertilizer out of the cave and visitors in. He is holding a kerosene torch. NPS photo.

lightning speed, agents of the Service assessed the cave for its national significance, and Carlsbad Cave National Monument was created by President Calvin Coolidge on October 25, 1923.[7]

Deliciously eccentric as the twentieth century progressed, a romantic relic of an earlier time, and a fabulous teller of tall tales who envisioned the caves as more than a source of guano, White created a place in the national consciousness for the great caverns, a template through which mid-century America could understand the mysterious depths of Carlsbad Caverns. In this sense, he became the living embodiment of the cave during its transformation from a hole in the ground to source of guano to "eighth wonder of the world."[8]

Publicity about the caverns increased exponentially, culminating in two extensive feature articles written by geologist Willis T. Lee for *The National Geographic Magazine*. The first appeared in the January, 1924 issue and a second article by Lee followed a year later in the September, 1925 issue. It is likely that these articles sparked the interest of the first artists to enter Carlsbad Caverns—Santa Fe painter Will Shuster and his friend, fellow artist Walter Mruk, who dropped into the new national

monument via a guano bucket and winch in 1924.

"Like Rough, Underground Mountain Climbing"

…we'd go down into the caverns with [Jim White] and when he wasn't around we got to know the lay of the land down there, which is pretty rugged. We climbed down the ladders ourselves and prowled around in the dark, each carrying two lanterns and a little pack with food, drawing materials, and we put the lanterns off in the formations and worked by the light of another one. That's the way we worked it, and each night we'd come out and swear that we'd never go down there again. It was rugged, like rough underground mountain climbing.[9]

Will Shuster (1893-1969) was one of Santa Fe's best-loved personalities and a true creative force in the community for many years. Having settled there in 1920 for the healthy climate, "Shus" proceeded to become a fixture in the art community. His best-known contribution to Santa Fe culture is probably his invention of "Zozobra" in 1926, a huge, puppet-like effigy of "Old Man Gloom," which to this day is burned every year at the Fiesta.[10] The painter John Sloan began to work with Shuster and

encouraged him to become more serious about his painting. Shuster and Sloan remained close friends for many years. In 1921 Shuster founded Santa Fe's first modernist art group, *Los Cinco Pintores* with Jozef Bakos, Fremont Ellis, Willard Nash, and Walter Mruk. Known as "the five little nuts in five adobe huts," the unconventional artists cut a wide, playful swath through the conservative atmosphere of prohibition-era Santa Fe.[11] According to Shuster, the young group "banded together mainly for exhibition purposes. You might say self-protection from the elders…we were the wild harem scarems, you see, at the time."[12]

In 1924, Shuster and fellow *Cinco Pintores* artist Walter Mruk (1895-1942) heard about the excitement going on down near Carlsbad,

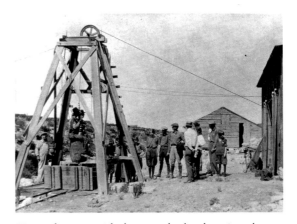

Visitors line up to ride the guano bucket down into the cave in this photograph dated August 21, 1924. The building at right housed the gasoline engine that drove the winch. This is the same contraption that carried the first artists into the depths. Photo Willis T. Lee, courtesy of Carlsbad Caverns National Park.

Green Lake *by Will Shuster. Oil on canvas, 48" x 36". This is one of several paintings that Shuster donated to the National Park Service. In need of restoration, the painting will eventually be cleaned—revealing even more vibrant colors. NPS photo, courtesy of Carlsbad Caverns National Park.*

Carlsbad Caverns Number 2 *by Will Shuster. Oil on canvas, 36" x 30" 1924. This painting may have been based on the Devil's Spring (also referred to as "Yeitso's Pillar by Willis T. Lee), one of the few large pools of water along the visitor trail. Courtesy of Owings-Dewey Gallery, Santa Fe NM.*

Scene of Carlsbad Cavern *by Will Shuster. Oil on canvas, 48" x 36". Shuster's paintings demonstrate a remarkable sensitivity for the structures of cave formations; Shuster used exaggerated brushstrokes in the foreground to represent the nubby texture known as "popcorn" that coats many formations in the cave. NPS photo, courtesy of Carlsbad Caverns National Park.*

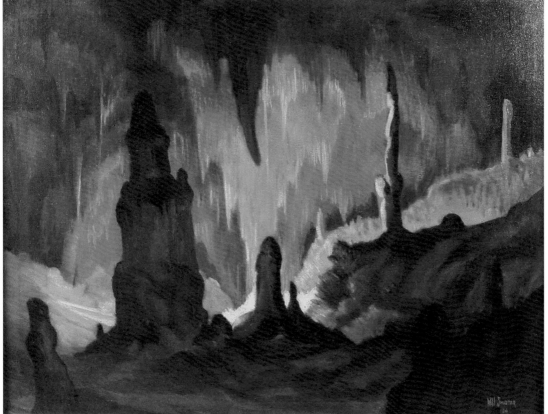

Top left: Carlsbad—Gold *by Will Shuster. Oil on board, 10 ¾" x 15 3/8" no date.* Top right: Carlsbad—Blue *by Will Shuster. Oil on board, 12" x 16" no date. These are oil sketches Shuster probably made in 1924 in preparation for larger paintings. Both images are courtesy of Owings-Dewey Gallery, Santa Fe NM.* Queen's Chamber *by Will Shuster. Oil on canvas, 30" x 40". NPS photo, courtesy of Carlsbad Caverns National Park.*

Walter Mruk and Will Shuster preparing to descend into Carlsbad Caverns during a 1924 painting expedition. Photographer unknown, courtesy of the Museum of New Mexico Press.

and drove out to the cave. They were there at the same time that Dr. Willis T. Lee was encamped with his entourage for several months of survey and photography in preparation for his second *National Geographic* article.[13] Shuster and Mruk found all the adventure and inspiration two vigorous young artists could hope for. No doubt grateful for the primitive trails established by Jim White, they made numerous trips into the cave, setting up lanterns in various areas and making small sketches that became the models for larger work; Shuster alone made at least eight large paintings and several smaller oil sketches. Another small, undated etching of the cave also exists. It is not known how many paintings were made by Mruk, since much of his work has been lost over the years due to fire and damage from poor storage practices. It is doubtful any of Mruk's Carlsbad paint-

ings have survived. Since he only lived in New Mexico for a few years, and returned to the east in 1926, less was written about him than other *Cinco Pintores* members.[14]

The experience of being the first artists to portray the wonders of Carlsbad Caverns was undoubtedly exciting for both men, and it appeared to have had a powerful impact on Shuster in particular. Describing the cave's effect on his work, Shuster stated "The cave has made a cubist, vorticist and post-impressionist of me against my will."[15]

In the January 14, 1925 issue of the *Santa Fe New Mexican*, an exhibit of Shuster's cavern paintings at the "New Museum in Santa Fe" was described as "One of the most notable ever seen here."

This collection of canvases has created a stir in the art world, not only because the visit of Mr. Mruk and Will H. Shuster was the first that resulted in canvases of the cavern, but Mruk's canvases are said to be imaginative to a high degree. He filled the cavern with mythical grotesques in an effort to interpret his reaction upon entering the dim [sic] lit interior. The work is accepted as a distinct achievement, although decidedly unusual, and difficult of treatment. Art critics have differed widely over the paintings, although all have conceded an impressive result.[16]

Apparently, Shuster was less than pleased with the reactions his cavern paintings generated. Eastern critics may have been unimpressed by the works, possibly because they lacked any visual frame of reference for the unusual imagery. In a letter from Sloan to Shuster dated March 4, 1925, Sloan addressed Shuster's disappointment:

I suppose you had hoped too much from the Cave stuff and it blued you to have the bottom fall out of your hopes—just forget it—put 'em away and come to the surface of the Earth again. Perhaps its [sic] time for me to tell you that I never could really understand your interest in the bowels of the Earth—I did like the pictures and

Untitled etching by Will Shuster, 2" x 3" no date. Courtesy of Owings-Dewey Gallery, Santa Fe, NM.

Carlsbad Caverns Trilogy, 1928, by Raymond Jonson. Oil on canvas. This triptych is the second in a series of monumental "trilogies" painted during Jonson's lifetime. Left- and right-hand panels 40" x 60"; center panel is 36" x 36". Total length of installed triptych is 180." Collection of The Albuquerque Museum, Gift of the Albuquerque Museum Foundation (1981.26.1a-c).

I saw how you enjoyed painting them and I'm sure they were great technical exercises and well done and I felt you had to get 'em out of your system—but if my advice is worth anything you can have it:—come back to human life—[17]

Obviously, Shuster's enthusiasm for the cave never waned, as he returned again in 1934 to make another series of paintings as part of the WPA New Deal program (See Chapter Three). Fortunately, another artist was fascinated by the caverns and made an early exploratory foray to the underground wilderness.

"A Hell Of A Hole In The Ground"

Raymond Jonson (1891-1982) left a successful career as a lighting, stage set, costume and graphics designer for the Chicago Little Theatre in 1922 after being deeply affected by the Santa Fe landscape during a camping trip. "I suddenly realized that this was a turning point and a new beginning was necessary."[18] The title of this section was a statement Jonson made to describe his impression of Arizona's Grand Canyon, but it could have easily applied to Carlsbad Caverns as well. A 1927 visit to the Grand Canyon inspired Jonson to create a monumental three-panel painting called *Grand Canyon Trilogy.* The completed work has a combined width of over thirteen feet.

Carlsbad Caverns Trilogy, *1928 (detail). Jonson combined naturalistic forms with completely abstract ones in his depiction of the caverns. He would later abandon nature-based imagery in favor of pure abstraction. Collection of The Albuquerque Museum, Gift of the Albuquerque Museum Foundation (1981.26.1c).*

In keeping with his tendency to create work in a rather closely related series, Jonson's next trilogy was based on a 1928 visit to Carlsbad Caverns. He was spared the awkward guano bucket descent, since a wooden stairway had by then been built from the natural entrance down to the bat cave level. Jonson's on-site drawings resulted in another monumental three-panel work, though the original drawings were probably destroyed (Jonson typically discarded preliminary sketches when the final work was completed).[19]

Carlsbad Caverns Trilogy was the second in a series of trilogies that would comprise a total of sixteen works spanning forty-six years. Eight years passed between the Carlsbad painting and his next trilogy, during which time Jonson discarded his interest in nature-based representational forms in favor of pure abstraction.[20] A powerful sense of connection resonates in Jonson's work, and he explored this spiritual aspect of his creative life even more deeply later in his career when he founded the Transcendental Painting Group in 1938. During his tenure as Professor Emeritus at the University of New Mexico in Albuquerque, he established the Jonson Gallery in 1950 on the UNM campus. The gallery served as New Mexico's premier modern exhibition space at the time.[21]

Jonson made this statement about his work:

I think some years ago, I created my own environment and I am still working in it. You might call it an inner environment if you like. My works are really contrasts to the environment in which they exist. Around us we have realism, strife, pain and greed. I wish to present the other side of life, namely the feeling of order, joy and freedom.[22]

Perhaps it is a sense of being able to relate to the passing of "geologic time" that causes some artists (and many cavers) to seek out the underground world again and again. When he was seventy-one, Will Shuster expressed his desire for an alternative experience of time in a 1964 interview conducted by Sylvia Loomis for the Smithsonian Archives of American Art:

You know, one thing I feel in my own life is that we place too much emphasis on time. I think time is a man-made thing. It's really artificial. They've gotten so they split it into microseconds now, but there is too much emphasis on time and not enough on nature or natural phenomena, living with the sun and with the seasons rather than this drive, drive, drive—I've got to get there in a hurry, got to get it over with…constant push of time. Everybody being pushed by time or running after it.[23]

During the one hundred and ten years since Jim White's discovery of The Bat Cave, man-made time has usurped the role of geologic time in altering the cave environment. Change that was once accomplished over eons, through the action of dripping water, yielded to the more immediate force of dynamite and shovels. While early explorers had to risk life and limb to plumb the depths of the enormous cavern, today's visitor has the luxury of walking 750 feet down a smoothly paved trail from the entrance to the cave's "Big Room" area. If that weren't enough, visitors who are pressed for time can opt to ride a fast-moving elevator from the surface straight down to the Underground Lunchroom. Indeed, in a world where "saving time" is of the utmost importance to many people, one wonders whether it is even possible for them to grasp the immense span of time represented by the cave's massive formations and carved galleries.

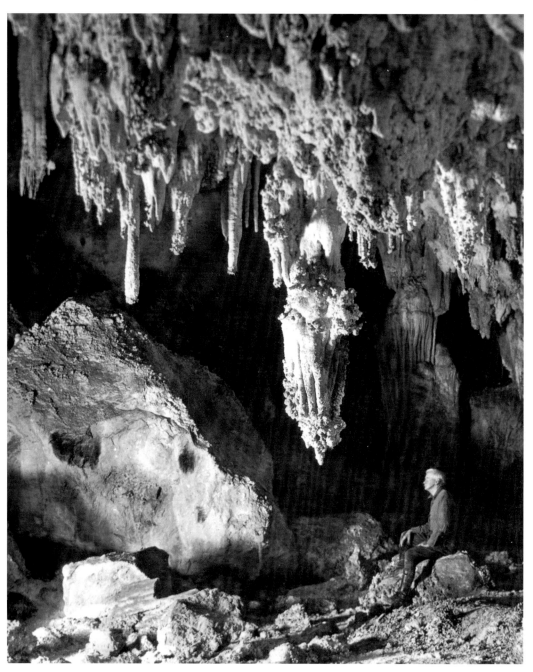

Geologist Willis T. Lee in the King's Palace, an area he attempted to rename "Shinav's Wigwam." This image appeared in the September, 1925 issue of The National Geographic Magazine. *NPS photo.*

Chapter Two
The Intrepid Photographers, 1900-1930

At the turn of the century, equipment that could infuse enough light into the void of The Bat Cave to produce adequate photographic images was still being developed. The photographic pioneers of Carlsbad Caverns probably saw themselves more as tinkering inventors than fine artists.

As world-class cave photographer Dave Bunnell writes, the essence of underground photography was (and still is) the process of using light to "paint" an image onto the blank palette provided by absolute darkness.[1] Once an individual leaves the "twilight zone" just inside the cave's entrance, he must provide all the lighting for any photograph. This challenge provides today's photographers with unique opportunities to explore the techniques of time exposure, multiple moving light sources, etc. In the early 1900s, it was a vexing problem that pushed photographic technique to the limit.

In 1866, Charles Waldack (c.1831-1882) used magnesium tapers to photograph the vast chambers of Mammoth Cave in Kentucky. He developed methods of positioning his magnesium lights to the side of the camera, to maximize relief and reduce the effects of reflective glare from airborne particles and humidity. Though magnesium produced intensely bright light, it also generated copious amounts of smoke, which had to be allowed for while planning successive photographs in the same area.[2]

Of the thousands of people that have photographed Carlsbad Caverns since it was discovered, several individuals have figured prominently as early documentarians of the cave: George Adams, Ray V. Davis, Robert Nymeyer, and Willis T. Lee.

The Thrill of Exploration: George Adams

The teenage son of a Carlsbad sheep rancher, George Adams (1892-1981) took what is perhaps the first amateur photograph of the

cave, circa 1908. Using one of the new Kodak Pocket cameras, he posed in a self-portrait at the Devil's Spring (also called "First Spring"). This beautiful area contains the first substantial body of water encountered by visitors to the cave, and has been a popular resting place since the early years.

Adams had heard talk of a big cave southwest of town, and decided to see it for himself. In a mule-drawn buggy, the trip out to The Bat Cave from the town of Carlsbad took several bone-jarring hours. Since there were many easily accessible caves close to town, this was quite a commitment of effort. After failing to meet up with their guide Jim White at the cave per their agreement, Adams and his friend Oppie Wallace decided to enter on their own rather than have nothing to show for their long, arduous trip.

Arriving at the cluster of shacks that marked the guano mining operation, they realized no one was there, so the boys located some of the crude spouted metal cans with wicks used by the miners. They scrounged enough kerosene from a nearby cask to fill four torches—two for the trip in, and two for the trip out. Like their contemporary successors—cave divers—light had to be rationed as if it were breathable air. Once it was gone, the trip ended, whether you were out of the cave or not.

They descended into the cave through the guano mining shaft, which had been blasted through a thin spot in the cavern's limestone ceiling. Because there was no operator to run the gasoline winch that lowered the large guano hauling bucket, they were forced to follow a series of rickety wooden ladders 185 feet down to the floor of The Bat Cave.

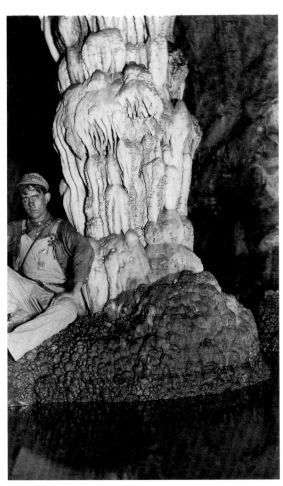

This self-portrait by George Adams is probably the first amateur photograph taken inside the cave, circa 1908. Courtesy of Carlsbad Caverns National Park.

The miners had removed bat guano by digging deep trenches through the deposit. In some areas, the guano was almost 100 feet deep, residue of a bat colony that numbered in the millions and had reared its young there each summer for millennia. Adams and Wallace followed one of these trenches out of the mining site and into the main cave. At that point they noticed a freshening of the air, which was a relief after the acrid stench of the bat roost. Following the trend of this enormous new passage, they traveled deeper into the cavern. Eventually, they heard dripping water and their lights glinted off a pool on the left side of the passage.

"That water really did look good, and it tasted even better," Adams said. "And that big white column standing there looked just like the Statue of Liberty. 'I've got to get a picture of this!' I exclaimed to Oppie. So I set up my camera, and Oppie said I ought to be in the first picture; so he held the flash gun, I opened the shutter and sat down by the white pillar, and Oppie struck a match and fired the flash sheet. It blinded me because I was looking right at it, after so long in the dark, but I knew we had a picture."

Adams describes flash sheets as

…thin slips of magnesium foil, about four inches square. We used a metal shield about twice the size of the sheets; it had a polished reflecting surface with a clip at the top to hold the flash sheet, and there was a small hole in the middle of the shield. This shield had a handle back from the bottom so the flash wouldn't burn the fellow holding it. When everything was ready for the picture, the man with the flash just lit a match, pointed the gun in the direction of his subject, poked the burning match through the hole, and lit the sheet. It burned with a bright flash and made quite a light. If we thought we needed more light, we just put two sheets in the clip.[3]

Before his death in 1981, Adams commented on the improvements made by the National Park Service over the years. "The paved road, the smooth trails, the elevators, the underground lunchroom, the mobs of people. And those wonderful electric lights. All this is great and necessary, I realize this, but [it] has robbed the cavern of one thing—that is the thrill of exploration. I will never forget that."[4]

Visions of a National Monument: Ray V. Davis

I enter upon this task with a feeling of temerity as I am wholly conscious of the feebleness of my efforts to convey in words the deep conflicting emotions, the feelings of fear and awe, and the

desire for an inspired understanding of the Divine Creator's work which presents to the human eye such a complex

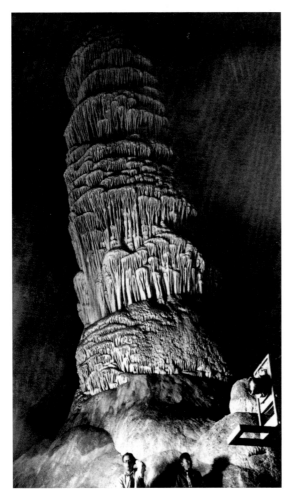

This photograph of the Giant Dome in the Big Room of Carlsbad Caverns captures Nymeyer himself next to Eugene Davis (Ray's son). Taken in 1928, Ray Davis' 8"x10" camera can be seen at the right side of the picture. Courtesy of Carlsbad Caverns National Park.

aggregate of natural wonders in such a limited space…Most of these pictures tell the story better than I am capable of doing.

(Robert Holley of the General Land Office, in his report recommending the creation of a national monument to encompass The Bat Cave, March, 1923. Ray V. Davis took the "pictures" to which he refers.)[5]

While most visitors to Carlsbad Caverns National Park are at least vaguely familiar with the folk icon Jim White and his role as early explorer of the cave, it is much less likely that they have ever heard of the photographer Ray Vesta Davis (1894-1980). In fact, Davis' role in the promotion of the cave as a world-class wonder cannot be overstated.

Bob Hoff served as historian at the caverns for many years and wrote several significant articles about Ray Davis and other prominent aspects of the park's history. He described the fortuitous meeting of two great explorers:

Sometime around 1915-1918, the paths of Jim White and Ray V. Davis crossed, and Jim invited Ray to the caverns to take pictures. Davis, twelve years junior in age to White, fell in love with the cavern just as White had himself years before. Almost immediately, Davis, like White, also realized the need

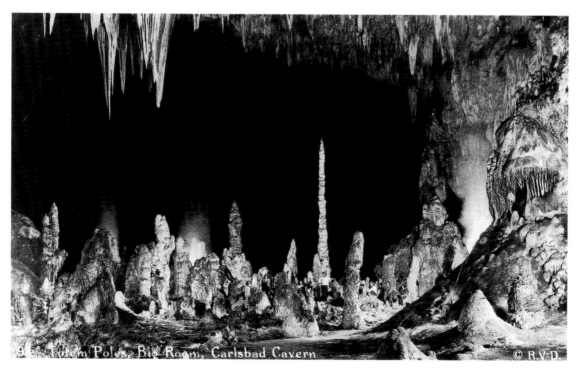

Through extensive trial and error, Davis perfected his techniques of photographing in the cave. Note the smoke from the magnesium flares lighting this shot of the Totem Poles in the Big Room. Photo by Ray V. Davis, courtesy of Carlsbad Caverns National Park.

to make known the caverns in order to share it with others. With White guiding Davis in the caverns and Davis taking photographs, the key combination for bringing the caverns to the attention of the world began, starting the changes that would evolve the "Bat Cave" as an early 20th century bat guano mining site into a National Monument in 1923, a National Park in 1930, and a World Heritage Site in 1995.[6]

Though the exact date of Davis' first trip into the cave with White has been lost to memory, Davis maintained a clear recollection of his impressions. After moving through the relatively featureless area of the cave where guano was mined, Davis began to catch glimpses of the cave's true nature. "My first view of the stalagmites and stalactites was by a flickering coal miner's kerosene lamp, but even so I saw at once that here was something the whole world should see…I could visualize millions someday coming to see them."[7] It is doubtful that Davis knew how prophetic his words were.

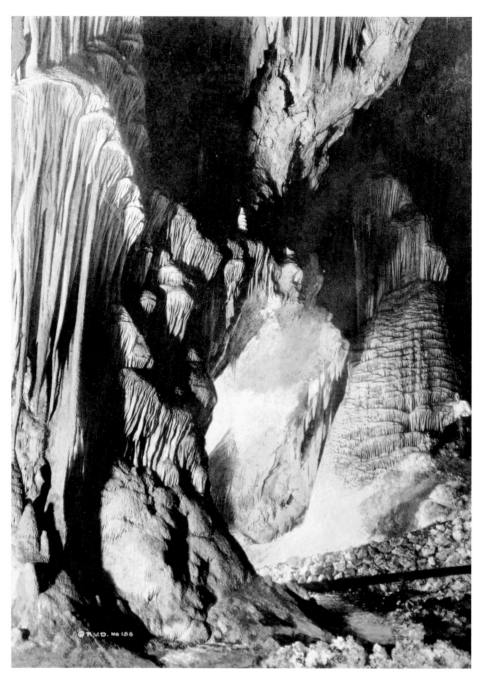

The Waterfall Formation in the Big Room, *hand-tinted photograph. Note the figure at the far right for scale. Photo by Ray Davis, circa 1928, courtesy of Carlsbad Caverns National Park.*

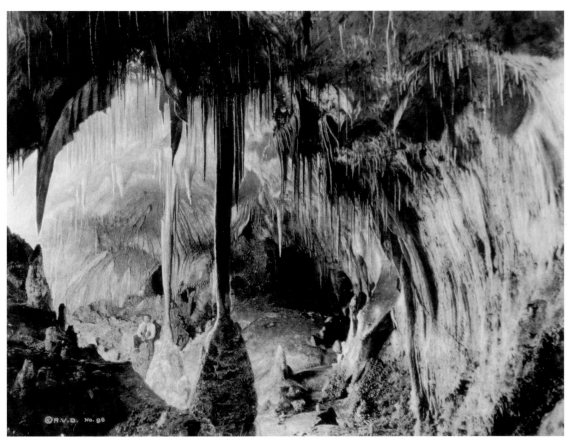

The Dome Room *is a small chamber off one side of The Big Room. This area became popular for weddings due to its baroque draperies and intimate scale. Hand-tinted photo by Ray V. Davis, circa 1928, Courtesy of Carlsbad Caverns National Park.*

Davis described his camera outfit:

I used a 5x7 or 8x10-inch camera, which required a heavy tripod. I took in a lot of magnesium powder (flash-bulbs were yet to come), as film speeds were very slow. This gear weighing seventy-five to one hundred pounds, I tied some to my back so as to have one hand free. Without something to hang on with, there were places I could slide 100 feet or more once we'd begun to explore.[8]

After a four-hour trek following Jim White, Davis took his first picture of the cave in the King's Palace, a large, flat-floored chamber that is heavily decorated. In his book, *Carlsbad,*

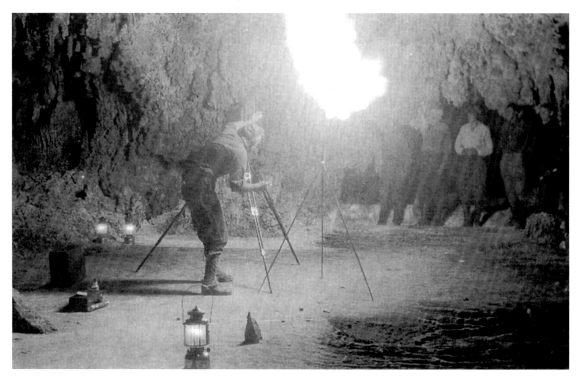

This photographer is using Ray Davis' flash equipment, at what appears to be great personal risk to himself and his subjects. Photo circa 1924 by Dana Lee, courtesy of Carlsbad Caverns National Park.

Caves and a Camera, Robert Nymeyer wrote with great admiration about his mentor's innovative lighting methods (Nymeyer served as Davis' assistant for several years beginning in 1928.) Davis experimented with "simple hand-held railroad flares of the type used on the railroads, to flash-powder guns, to an alcohol-magnesium burning floodlight which he designed and built himself."[9] Davis managed to capture both the magnitude and delicacy of the caverns, as they had never been seen before. Even by today's standards, Davis' photographs are marvels of sharp detail, pleasing midtones and high contrast, creating mysterious subter-ranean tableaux through the use of multiple light sources.

Together with Jim White, he began to spread word of the cave to anyone who would listen and glance at his photographs. Tirelessly, and with his own money, he printed thousands of postcards and 100,000 windshield stickers that read: "We visited Carlsbad Caverns, Photographed by Ray V. Davis." Word of the caverns spread like wildfire, and by 1922, the cave had become a regional attraction of the first magnitude.[10]

New Mexico had only been a state since 1912, and already it seemed that the southeast-

ern corner had seen its best days. Agriculture and ranching had grown stagnant, their value unable to keep up with the cost of goods manufactured in the nation's industrial centers.[11] The growing popularity of Carlsbad Caverns provided a much-needed boost to the local economy, and tourism became an economic factor for the first time. In 1916, Congress established the National Park Service, and the young agency was working hard to establish itself with significant holdings across the West. Davis' energetic promotion of the caverns caught the eye of Park Service administrators, who began an assessment of the area.[12]

The General Land Office (GLO) sent Roswell-based Mineral Examiner Robert A. Holley to verify or disprove the stories of the great cave. He surveyed the cavern in April and May of 1923, during which he traveled deep underground, guided by Jim White and Ray Davis. He emerged unscathed but not unchanged and waxed rhapsodic about the awesome wonders he saw. His report, an excerpt of which appears on page 21, along with the enthusiastic support of other governmental types who subsequently visited the cavern, prompted President Calvin Coolidge to establish Carlsbad Cave National Monument on October 25, 1923.[13]

The *National Geographic* Expeditions: Dr. Willis T. Lee

It occurs to me, as we descend with starts and jerks, to wonder whether certain vivid descriptions in *Divina Comedia* were written after Dante had been lowered into a bat cave in a guano bucket.[14]

Dr. Willis T. Lee (1865-1926) was a scientist, and deftly wielded all the influence to

Dr. Willis T. Lee took this self-portrait in 1924 next to a stalagmite encrusted in calcite "popcorn." Courtesy of Carlsbad Caverns National Park.

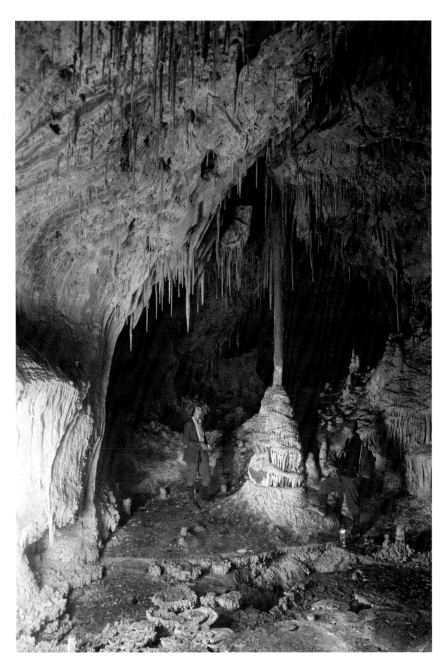

This image shot in the Dome Room by National Geographic Society Photographer Jacob Gayer in 1924 was the first color underground photograph ever made. The figure at left is Willis Lee's daughter Elizabeth. The identity of the figure at right is unknown. Photo courtesy of the National Geographic Image Collection.

which that title was ascribed in the early part of the twentieth century. Highly educated, he worked as a geologist for the United States Geological Survey. He was a member of the prestigious Explorers Club and the Cosmos Club. Lee had the ear of academics and bureaucrats, and parlayed his influence into a long-term assignment to study the cave for the National Geographic Society.

His first visit occurred in 1923, when he was in the Carlsbad area for other Geologic Survey business. He made the acquaintances of Ray Davis and local hard-luck rancher Carl Livingston and toured the cave with them, taking photographs and marveling at the vast chambers and decorated areas. It seemed Lee fell almost immediately under the cave's spell, and he submitted a substantial article supplemented with Ray Davis' photographs to *The National Geographic Magazine*, which was published in its January 1924 issue.[15]

Not content with what he knew was a cursory examination of the cavern, Lee contrived a plan by which to persuade the Society to bankroll a major scientific expedition to explore and survey the cave. He called on his friend Carl Livingston to provide evidence that would convince the society to agree. Shortly after Lee returned to the East, Livingston wrote, "I received a telegram from him reading: 'Send a runner post haste to the mountain fastnesses and procure for me the skull of an ancient man. Send the skull post haste.'"

The stratagem worked. The skull, an artifact from the archaic Basketmaker culture, appealed to the current fascination among intellectuals with all things archaeological, and the details from Lee's first article piqued the Society's interest in the cave itself. Armed with a hefty $16,000 grant and a team of researchers, Lee returned to Carlsbad Cave in March of 1924 and remained for seven months.[16] His crew included guides Jim White and Carl Livingston. Ray Davis provided guidance as Lee honed his own in-cave photographic skills. Lee also brought his two children—his twenty-one-year-old daughter Elizabeth and nineteen-year-old son Dana, who proved to be avid explorers and capable team members. Both assisted with photography and appeared in many of the pictures.[17]

This landmark expedition brought to light for the first time the true expansiveness and variety of the cavern and its formations. The press, with dramatic flair typical of the era, described "Rare cave 'pearls,' odd ornaments made by Nature out of the same sort of Oriental alabaster as some of Tutankhamen's vases." Another florid paragraph stated, "Here water has made a war club, again it has woven the finest stone lace. There are a number of places that might have come from the famed sun gardens of Bermuda."[18]

In September of 1925, Lee's second article was published in *The National Geographic Magazine*. The official photographer of the

Society, Jacob J. Gayer, created the first underground color photograph ever made, using a type of photographic transparency film called "Autochrome" that was patented in 1906 by Auguste and Louis Lumiére.[19] The subject was the Dome Room, a relatively small alcove off the Big Room that later became a popular area for weddings due to its dramatic, crenulated white stone draperies and intimate scale.[20]

In keeping with the popularity of literary references to obscure antiquities and mythical tales, Lee enthusiastically granted Native American names to significant areas of the cave that already bore serviceable, if uninspired, titles. "First Spring" became, in Lee's article, "Yeitso's Pillar." The "Jumping Off Place" was renamed "Shipapu's Hole." Probably to Dr. Lee's chagrin (and no doubt to the great relief of Jim White), those new names with which he christened the wonders of Carlsbad Cavern never caught on in the vernacular of the National Park Service.[21]

Carlsbad, Caves, and a Camera: Robert Nymeyer

We survived cave-ins, falling rocks, disorientations of both short and long duration, climbing disasters, and various encounters with assorted members of the animal and insect kingdoms. We knew the discomforts of bruises, scratches, and wounds both great and small. Bone-chilling water and perspiration-producing heat were a part of that way of life…Often we wondered if what we found was worth the effort, and then some new-found underground wonder would burst upon us, and we realized that it was.[22]

Few individuals have come to know the Guadalupe Mountains and her many caves as intimately as Carlsbad native Robert Nymeyer (1910-1983). His love affair with caves began in 1926 when he visited Carlsbad Cavern at the age of sixteen. In his amazing memoir *Carlsbad, Caves, and a Camera*, he described the trip into nearby Spider Cave and the moment when cave exploration entered his blood permanently: "For the first time, I crawled up an unexplored tunnel, negotiated a tight pinch, and stepped out into a virgin cave stretching far beyond the limits of my flashlight. For the first time, I knew the thrill of 'She goes!'"[23]

The escarpment that makes up the Guadalupe Mountains stretches in a long arc from Texas up through southeastern New Mexico. Marking the edge of an ancient sea, the 250 million-year-old uplift provides the world's best example of an exposed, fossilized Permian-era reef. During eons of burial and exhumation, and thanks to the sulfuric acid-laden water provided by nearby oil and gas deposits, the limestone of the reef is honeycombed with hundreds of caves.[24] Some are grand geologic

Robert Nymeyer photographed this view looking out the entrance of Carlsbad Cavern in 1926. It was his first photograph in the cave. Visitors at this time were able to walk into the cave via a staircase from the Natural Entrance. Courtesy of Carlsbad Caverns National Park.

cathedrals like Carlsbad Caverns and Lechuguilla Cave; others are little more than glorified worm-tubes too small for human passage. At a time when the locals held little regard for the area's disreputable holes in the ground, Robert Nymeyer made it his life's work to become familiar with them all.

Fortunately for history, the photographic bug also bit Nymeyer hard. He experimented with many types of cameras and lighting setups:

After my first two or three attempts at cave photography with a cheap folding pocket camera of uncertain origin and poor quality lens, I realized that if my underground photographs were to improve, I would have to get a better camera. I managed to trade for an excellent used folding Eastman 2-C Autographic Kodak Jr. This used the size 130 roll film with six exposures, making a negative 2 ⅞ by 4 ⅞ inches,

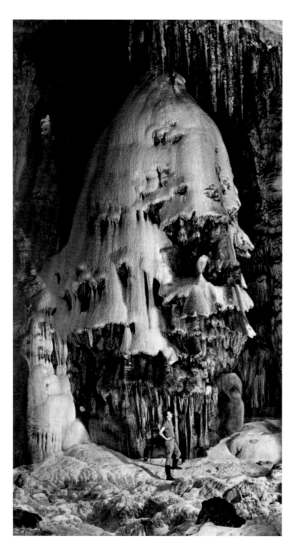

Robert Nymeyer perfected his photographic skills in the backcountry caves of the Guadalupe Mountains. This 1940 photograph of the Christmas Tree was taken in Slaughter Canyon Cave (Formerly New Cave), one of the many caves besides Carlsbad Caverns that are managed by the National Park Service. Courtesy of Carlsbad Caverns National Park.

only slightly smaller than the popular postcard cameras of that day. The camera was equipped with an Ilex shutter with time and bulb exposure, and timed speeds from one second to 1/100th of a second. The lens was an Eastman Anastigmat F:7.7, not very fast when compared with today's high-speed jobs, but it made negatives of fine definition and detail. It focused by a sliding front from infinity to six feet, and I modified this somewhat so as to be able to take sharp pictures down to a distance of only three feet.[25]

Nymeyer worked as a guide at the caverns for two summers in the mid-thirties, and received invaluable training as a photographic assistant to Ray V. Davis beginning in 1927. He worked with the "Rube Goldberg contraption Ray had designed and built for lighting his scenes. It seems a miracle now that at some time in his career he did not blow his head off." Davis combined an open pan that held magnesium flash powder with a rubber hose, which allowed him to propel the flash powder into an alcohol torch by blowing through the hose. When Nymeyer asked Davis what would happen if he accidentally inhaled instead of blowing, Davis replied, "I probably wouldn't be around for the next picture."[26]

Nymeyer enjoyed a long career exploring, photographing, and even discovering caves

in the Guadalupe Mountains. In the process, he collected enough hair-raising tales to fill a book—which is exactly what he did. *Carlsbad, Caves, and a Camera* is a monument to the region, and a fascinating glimpse into what drives cave explorers to endure hypothermia, falling rocks, bad air, darkness and discomfort as they pursue their "hobby."

A fortunate few today have the opportunity to travel beyond Carlsbad's visitor trails—as volunteers for the Park Service performing scientific study, mapping, and other activities—and they often experience a sense of unreality when moving from the "wild" sections of Carlsbad back into the areas that have been "tamed" for the general public. This must be particularly intense for someone like Nymeyer, who spent so many years crawling through "undeveloped" caves. After returning from a trip to the Lake of the Clouds in the mid-1970s, Nymeyer described this feeling with great sensitivity in his book:

Later, as I walked, numb, along the pavement, to emerge finally into the glare of electric lights and stagger into the sterile, metallic square of the elevator car and rise in one minute to the surface 750 feet above, I felt it was all unreal. The trip into the wild, untamed splendors of the virgin cave just beyond the blaze of electric lights seemed only a dream, a jigsaw puzzle whose pieces would never all fit together into one completed picture.

They never have.[27]

With the collaboration of caving legend William R. Halliday, M.D., Robert Nymeyer went on to write a second book entitled *Carlsbad Cavern, The Early Years: A Photographic History of the Cave and Its People.* This book is the most comprehensive history of the early photographers to date and provided a critical resource for this chapter. Sadly, Robert Nymeyer died before the book was published and no bibliography was produced. Still, it remains a tribute to Halliday and Nymeyer's many hours spent recording oral history from old timers whose stories would have otherwise been lost forever and picking through countless hundreds of old cavern photographs.

While the photographic history of the caverns begins with these colorful characters, it by no means ends with them. The proliferation of amazing cavern photographs in magazines and newspapers fueled a storm of curiosity that spread across the country like a Depression-era duster. A frenzy of tourism and exploration exploded at Carlsbad Caverns, and the National Park Service had to take quick, decisive action to protect its newest "Crown Jewel" park. Enter "The Colonel."

Carlsbad Cavern

This is the cavern. Here the Titans toiled
To rear this vast cathedral of the depths.
The waters hollowed it in aeons past
And drop by drop built up the stalagmites
And fluted stalactites here pendulous.
No word can picture all the loveliness
That Nature here has fashioned for the eye.
It may be Pluto here with Persephone
Held regal court while Vulcan forged
The draperies of their couch, and Psyche bathed
Within the Wishing Pool…
So much of beauty should have audience!
This is a palace grander than those reared by Kings;
Gigantic…and with spires marvelous;
A structure never reared by hands
But those of gods…The Rock of Ages stands
Older than Parthenon or Pyramids.
This pile was laid 'ere Moses gave the law;
Was old when Ninevah ruled all the land,
Or lost Atlantis sank beneath the sea.
Here, pompous man sinks into nothingness…
His deeds must pall before the infinite.
This was the realm of gods 'ere Time began…
And while man built his puny walls of stone
This realm of beauty was the home of bats!

William Felter
New Mexico Magazine, March 1935

Chapter Three
The Evolving Spectacle

America was not at her best during the 1930s. The economy was crippled and much of the heartland's windblown prairie sod blotted out the sun. Yet in some ways, this hard time brought out the best in our culture. Despite economic hardships brought on by the Great Depression, Americans still managed to visit a newly christened national park called "Carlsbad Caverns" in droves. Pictorial essays, poetry and literary effusiveness in publications like *New Mexico Magazine* fired the imaginations of Americans who needed to escape the oppressive struggle of their lives, if only for a day or two. To help the fledgling park become established, National Park Service Director Horace Albright placed Colonel Thomas Boles (1881-1972) in the Superintendent's chair. Beginning in 1927 and lasting for nineteen years, the reign of Colonel Boles ushered in the heyday of Carlsbad Caverns as a destination for tourism.

Managing The Eighth Wonder of the World: Colonel Thomas Boles

"Deliciously idiosyncratic and selected largely for his promotional skills, Boles was the quintessential first-generation park manager, an energetic jack-of-all-trades who knew how to meet people and how to spark their interest in his park."[1] A first-rate public relations man but a less-than-stellar manager, Colonel Thomas Boles entertained political heavy-hitters, celebrities, and regular folks alike with special programs in the cave and photo ops in his "studio," an alcove along the Big Room trail that Boles had designated as such.[2]

Boles took many photographs in the cave, though almost none survived after his death. Fortunately, one existing photograph in particular presents an iconic image of the cave's almost magical allure. Taken between 1930 and 1931, Boles photographed his young daughter Margaret as she stood, bathed in a shaft of light that pierces deep into the cave through

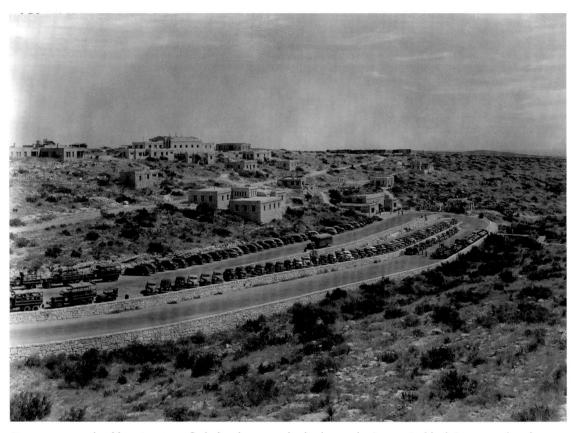

Despite economic hardship, Americans flocked to the caverns by the thousands. Cars in Carlsbad Caverns parking lot, circa 1930. NPS photo.

the Natural Entrance during a few weeks each year, near the summer solstice (see page 39).

Visitation at the caverns continued to boom, and the park began operating in the black almost from its inception. Large groups of visitors presented challenges to the rangers charged with the task of moving people through the cave without damage to the formations or the visitors. A traffic bottleneck on the trail was a recipe for disaster. Though a shutterbug himself, Colonel Boles took issue with the increasing popularity of amateur photography and its impact on the running of "his" cave:

Candid Cameras: Second only to house trailers, I believe that candid cameras are developing into somewhat of a nuisance in this national park. The amateur photographers are of course encouraged to take all of the pictures they want to on the surface, but it is certainly annoying when one

is conducting several hundred tourists through the cavern to have someone pull a collapsible tripod out of their pocket and set it up in the middle of the trail and delay hundreds of people, while the photographer makes a picture which probably could be purchased for five cents. Some visitors insist on putting their children on top of formations for a photograph, and openly resent our request that they remain on the trails, which after all is the safest place in the cavern. They seem of the opinion that we are depriving the Carlsbad Cavern of some favorable publicity, but at the same time I believe that protection of our formations against defacement, and safe conduct of our visitors over the underground trails, is of much more importance to the future of the Carlsbad Cavern than the possible publicity which might be obtained from an amateur who, nine times out of ten, knows little if anything about operating the Kodak.[3]

Indeed, Colonel Boles had a point. Early cameras were a popular novelty but photographic technique remained largely a mystery to most people. The absence of adequate light almost guaranteed that the visitor, upon returning home and developing his film, would likely end up with a series of poorly-focused, ghostly forms and shadows. The fact that photographers like Ray Davis had almost perfected the art of making pictures underground, and that their photos were available for sale at the park as postcards, souvenir booklets, pamphlets, and other memorabilia, rendered the typical visitor's attempts at photographic documentation moot.

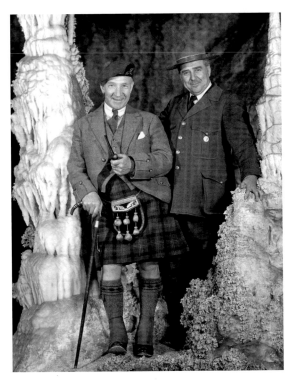

Colonel Thomas Boles poses in his "studio" with Scottish Entertainer Sir Harry Lauder in1932. NPS photo.

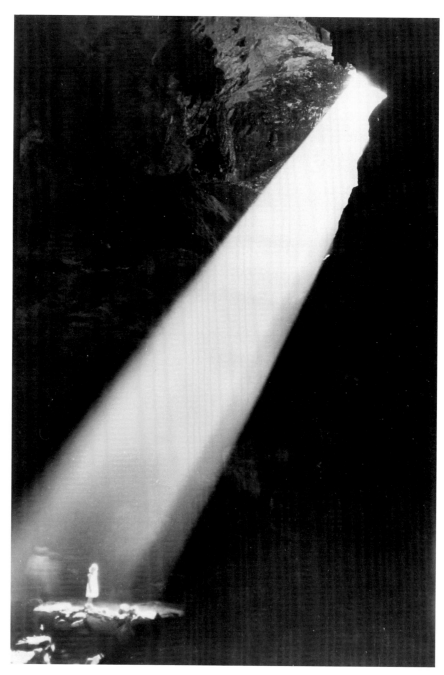

Colonel Boles took this iconic photograph of his daughter Margaret around 1930. NPS photo.

The First Woman Artist At The Caverns? Mercedes Erixon

Sometime in 1931, a young teacher named Mercedes Erixon traveled from her home in Oklahoma to visit the renowned Carlsbad Cavern. Erixon was the Head of Art Education at the University of Oklahoma, from which she graduated in 1926 with a Bachelor's of Fine Arts Degree.[4]

Though steady progress had been made in blasting a vertical shaft 750 feet down to the level of the Big Room, elevators had not yet been installed, so she would have joined several hundred other visitors on the six-mile

Formation of Carlsbad lithograph by Mercedes Erixon, 1931, number 4 in an edition of 12. This may be the first depiction of the cave by a woman artist. Courtesy of the National Cave Museum, Diamond Caverns, Park City, Kentucky.

round-trip trek from the Natural Entrance as it wound through the Main Corridor's vast wonders and finally down to the King's Palace, Queen's Chamber, and the Big Room.

Doubtlessly inspired by the cave, she returned home and that same year created a stone lithograph entitled "Formation of Carlsbad."

She may have made sketches in the cave, or worked from reference photographs by Davis or others. There were only twelve prints in the edition, and it is likely that very few survive. This may be the earliest known image of the caverns produced by a woman artist.[5]

Erixon went on to establish herself as an im-

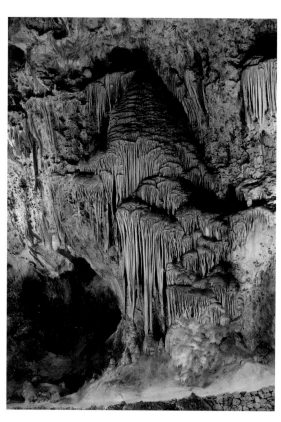

This hand-tinted photograph of the Frozen Niagara *formation shows the artful way that cavern formations were portrayed in postcards and other promotional materials. Photograph circa 1930 by Herbert Kennicott and George A. Grant, courtesy of Carlsbad Caverns National Park.*

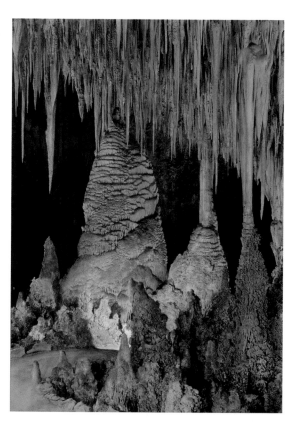

Temple of the Sun *with trail showing, hand-tinted photograph circa 1930 by Herbert Kennicott and George A. Grant, courtesy of Carlsbad Caverns National Park.*

portant artist during the WPA (Works Progress Administration) program established by President Franklin D. Roosevelt. This program helped many artists survive and continue creating art during the economic hard times of the 1930s. As a result of this program, which lasted from 1933 to 1943, hundreds of works of art in many media—paint, sculpture, literature, dance, theatre, etc.—were created with funding from the federal government.[6]

For the public who had received rich and often beautiful interpretations of the Southwest and for the artists who made these works, the New Deal art programs in New Mexico had fulfilled their mission. They had offered the "more abundant life" that Roosevelt wished for all Americans. For the first time art became for many part of their everyday life.[7]

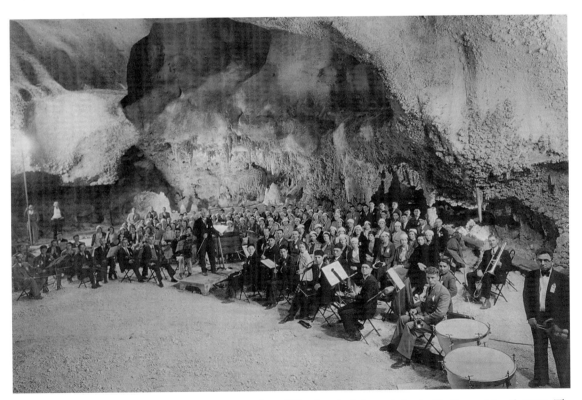

The Haydn Oratorio Society of El Paso about to perform "The Creation" Oratorio in the Big Room, May 6, 1933. The orchestra set up in a portion of the Big Room that was designated as the first Underground Lunchroom. The Lunchroom has since been moved to where it is today. Aultman Photo Co., NPS photo.

Telling His Own Story: James Larkin White

No account of the discovery and early exploration of Carlsbad Caverns would be complete without extensive mention of Jim White (1882-1946). A minimally educated, soft-spoken cowboy, he spent most of his life working at the caverns in one capacity or another. Beginning as a guano miner in the early days before the cave was made a national park, White made the transition from private citizen to government employee, and worked as chief ranger of the new Carlsbad Cave National Monument from 1928 to 1930. When the caverns gained national park status, Jim White's role was scaled back and he never gained the "chief explorer" position he coveted. However, he was granted a concession to sell his account of the discovery and history of the caverns, entitled "Jim White's Own Story." Floridly ghost-written in 1932 by Frank Ernest Nicholson, an explorer/journalist of dubious integrity, White sold this small booklet in the underground lunchroom for many years.[8] It is still available for sale today in the visitor's center bookstore.

Originally printed in rotogravure, the thirty-six-page booklet has a beautiful full-color cover with a photograph of the Twin Domes by Ray V. Davis. The interior is printed in two colors, with numerous rather degraded black and white photographs. Interestingly, the booklet contains a photograph of saguaro cacti, and in this way perpetuates a misconception initially established by the *National Geographic Magazine* in its January, 1924 issue featuring Carlsbad Caverns. In this issue, the division between the end of the article about the caverns and the beginning of the next article—an eight-page pictorial essay entitled "Fantastic Plants of Our Western Deserts"—was undetectable; with no title line on the second story aside from a small header across the top of each page, the casual reader would have assumed that he or she was

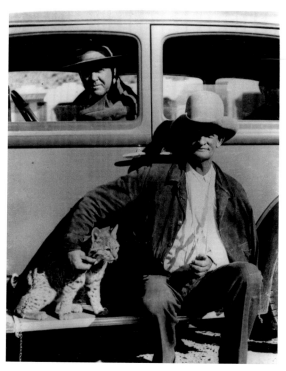

Jim White seated on the running board of a car with what appears to be a pet bobcat. His left arm is in a sling for unknown reasons. Photo circa 1931 by Roger Wolcott Toll, courtesy of Carlsbad Caverns National Park.

still looking at photographs of plants that grew near Carlsbad Caverns.[9] It is likely that many early visitors to the cave were disappointed to discover that not a single saguaro cactus grew anywhere in the state of New Mexico.

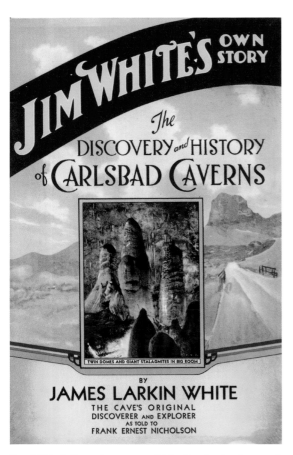

Jim White's Own Story was sold by Jim (and subsequently by his widow) in the underground lunchroom for many years. The book is still available at the park visitor center. Courtesy of Carlsbad Caverns Guadalupe Mountains Association.

A Sun Painting in Darkness: Pansy Cornelia Stockton

It has been written that the female members of the Santa Fe Art Colony were more *avant garde* than their male contemporaries. A native of Colorado, Pansy Stockton (1894-1972) moved to Santa Fe in 1941 and began to establish herself as one of the area's most unique artists. Her creative forebears included such luminaries as Olive Rush, Georgia O'Keeffe, and author Willa Cather. Like many transplants to New Mexico, Stockton was fascinated by the landscape and culture of the state: much of her work includes evidence of man's presence on the land—adobe houses, roads, and people. Her early work was fairly typical of the era—representational paintings in rich colors using oils, watercolors, and other media. Stockton found her unique style of expression when she began creating found-object assemblage using plant material and feathers. "My palette is composed of some two hundred and fifty types of colorful wild growing things from everywhere," she said.[10]

Stockton referred to her botanic assemblages as "Sun Paintings," and some of these works had as many as 10,000 components. On the backs of some of her Sun Paintings she listed the materials and where she found them. Obviously, Pansy Stockton considered the process of collecting the raw materials for her assemblages to be an intrinsic and powerful part of the creation of each piece.

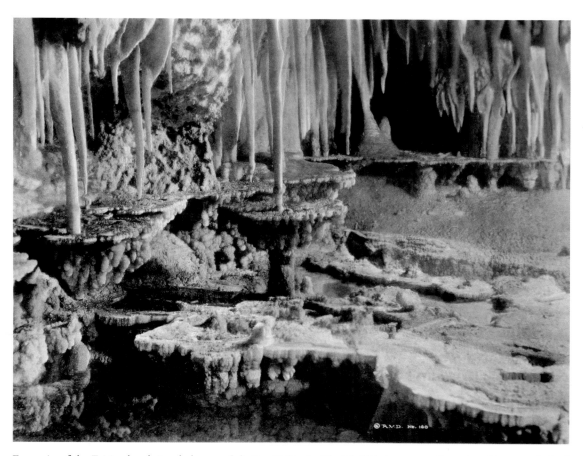

Fountain of the Fairies *hand-tinted photograph by Ray V. Davis. 6" x 8". This image was first printed in 1928 by Leck Studios, as part of a souvenir booklet sold to visitors, and was reproduced for many years as a postcard. It is probably the reference image Pansy Stockton used while creating her "sun painting" of the same title. Courtesy of Carlsbad Caverns National Park.*

It is interesting that she chose a sunless and nearly lifeless subject like Carlsbad Caverns for one of her Sun Paintings, but some time after 1941 she visited the cave and was inspired to create "Sun Painting—Fountain of the Fairies." The assemblage is undated. Various colored strips of bark and leaves make up the formations, while blue and green feathers symbolized water in a pool. It does not appear that Stockton used materials endemic to the Chihuahuan Desert (where the caverns are located) for her assemblage.

Pansy Stockton received national attention when the television program "This Is Your Life" featured her story. In addition, she was an honorary member of the Sioux Indian Nation, and five short films were made of her as she created her Sun Paintings.[11]

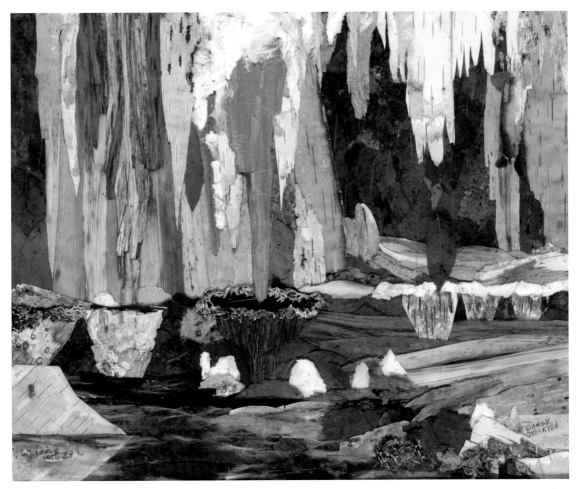

Sun Painting—Fountain of the Fairies *by Pansy Stockton, circa 1941. Botanical assemblage, 13 5/8" x 16 5/8". Stockton used bark, other plant materials, and feathers to depict this popular grotto in the cave. Courtesy of Owings-Dewey Gallery, Santa Fe, NM.*

Working For The New Deal: Will Shuster Returns To Carlsbad Caverns

Ten years after his first foray into Carlsbad Caverns in 1924, (see Chapter One) painter Will Shuster returned to the cave as part of the Civil Works Administration's (CWA) "Public Works of Art Project" (PWAP). This was the first federally-funded art program established by President Roosevelt to aid unemployed artists during the Depression. Shuster recorded his jubilation in a 1933 letter to his friend and mentor, painter John Sloan: "Forty two fifty a week from the Government for painting.

My God, it doesn't seem real. The day after I landed the job I had to go to bed. That's a big help."[12]

Superintendent Boles, ever mindful of visiting personalities, made an entry in his February 5, 1934 Superintendent's Report describing Shuster's visit. He noted that the artist spent "three or four days making sketches of Cavern interiors from which he will paint murals which will be placed on the walls of Federal buildings in New Mexico."[13] Shuster recalled that he was assigned a ranger to accompany him while he worked in the cave, and that the two of them were inadvertently plunged into

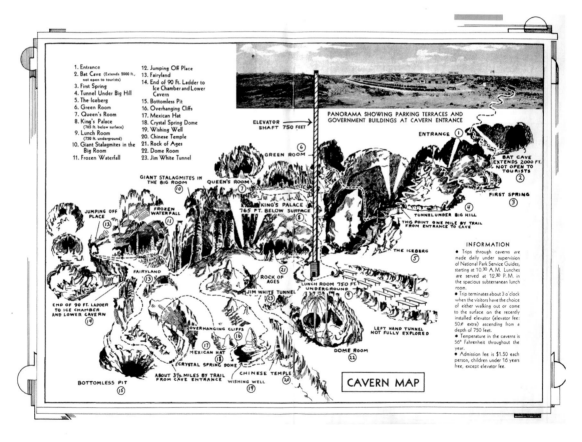

Map of Carlsbad Caverns from Jim White's Own Story, *circa 1932. Hand-drawn maps of this type were a popular way to depict the complex layout of the cave, though they were far from accurate. Courtesy of Carlsbad Caverns Guadalupe Mountains Association.*

darkness when the lights were turned off in the Queen's Palace where Shuster was sketching. The ranger, who had been off exploring, came back with a flashlight several minutes later and turned the switch back on.

In a 1964 interview with Sylvia Loomis for the Smithsonian Archives of American Art, Shuster described the work he did for the CWA as "four-by-six or four-by-eight panels. I think I did three or four." Famous Santa Fe print-maker Gustave Baumann was the field supervisor for the area, and would stop by Shuster's studio to check on his progress. Shuster made small color sketches in the cave and brought them back to his Santa Fe studio for enlarging. According to Shuster, the murals were never completed.[14]

Shuster's 1934 paintings were different from his earlier portrayals of the cave. Each canvas included a segment of the established visitor trail, which had not existed in 1924. In addition, the commercialized cave contained electric lights, which influenced Shuster's palette.[15] Though several books have stated that these paintings were donated to the National Park Service, no record of this gift exists. Only five paintings from the earlier 1924 series remain in the possession of the National Park Service; though Shuster initially donated several more, some were returned to the family.[16] As of this writing, none of the 1934 series of paintings has been located, other than three black and white reproductions from the files of the New

Mexico State Records Center and Archives, and one photograph from "Will Shuster: A Santa Fe Legend," the excellent biography by Joseph Dispenza and Louise Turner. One of the prints clearly shows Shuster standing in front of a small study attached to a larger painting of the same image on an easel (see page 48).

Sadly, it is not unusual for New Deal works of art to go missing. After the Depression ended and the WPA was dissolved in 1943, the federal government's interest in the tens of thousands of works of art created during the program waned. Since it is illegal to sell WPA works of art, many works were destroyed, lost to the elements, or simply distributed to private citizens.

The fate met by the paintings of the New York City FAP easel section in 1944 was typical: nine years' worth if fine artwork was sold as scrap-by-the-pound to a Long Island salvage dealer. Luckily—and this was not typical—a Lower West Side curio shop owner discovered the sale, bought the canvases and informed his artist friends. They were able to buy back many of their works at prices averaging $3 to $5 per painting and $25 apiece for the larger mural studies.[17]

In the mid-1980s, WPA-era art became a fad among American collectors, which in-

creased demand and raised the value of the art. At this point, the federal government regained its interest in these works—since all these pieces were created as part of a federally-funded program, they are considered to be Federal property and thus subject to seizure.[18]

Sometimes the only way a piece of art can be identified as being part of a WPA program is if the frame has a small brass placard identi-

fying it as such. Some works bear a label on the back identifying the work as WPA art. However, many works were re-framed over the years and these identifying tags were removed. In 1996 the Government Services Administration (GSA) published an inventory of over 17,000 works currently being held in non-Federal institutions or in the private sector. A second edition was published in 1999, entitled "WPA

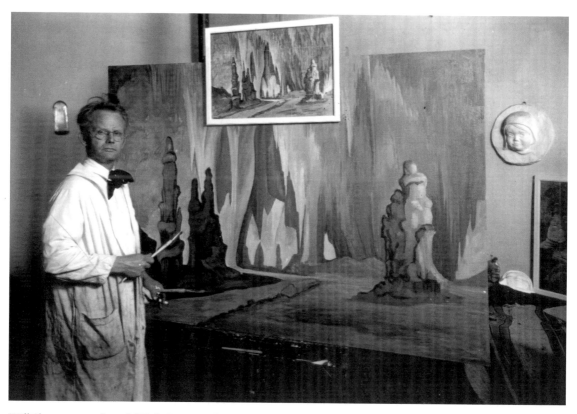

Will Shuster at work, *n.d. Works Progress Adminsitration Photograph Collection, Image 5499. Will Shuster poses in front of a painting and its smaller study, which was probably made in Lower Cave. Note that this image was created from the same vantage point used by Mercedes Erixon in her lithograph "Formation of Carlsbad" (see page 39). Oil on "prestwood panel," 1934, approximately 48" x 72." Courtesy of the New Mexico State Records Center and Archives.*

Artwork in Non-Federal Repositories, Edition II." Fortunately, many WPA works of art survived, and reproductions of art from this important era in American history are available. Numerous excellent books exist about WPA art, in particular *The New Deal: A 75th Anniversary Celebration* by Kathryn A. Flynn with Richard Polese (2008, Gibbs Smith Publishers) and *WPA Posters* by Chris DeNoon (1987, The University of Washington Press).

Ranger Doug's Enterprises was established by Doug Leen in 1993 after the discovery twenty years earlier of what appeared to be the only surviving WPA poster—Grand Teton National Park. A former National Park Service employee himself, Doug describes his quest for the "lost" National Parks posters:

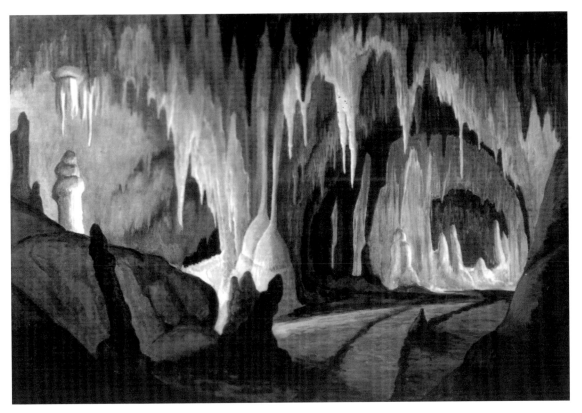

Carlsbad Caverns *by Will Shuster, 1934. Works Progress Adminsitration Photograph Collection, Image 5501. Oil on "prestwood panel," approximately 48" x 72." Courtesy of the New Mexico State Records Center and Archives. This is one of four WPA paintings Shuster made in 1934 that are unaccounted for.*

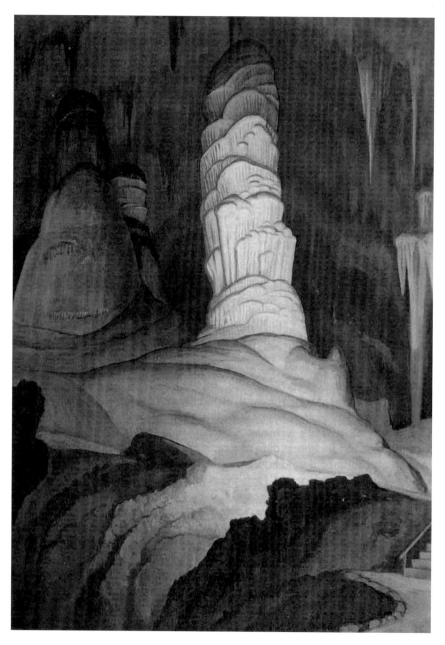

Rock of Ages *by Will Shuster, 1934. Oil on "prestwood panel," approximately 72" x 48". Photographer unknown, image appeared in "Will Shuster, A Santa Fe Legend". This is one of four WPA paintings Shuster made in 1934 that are unaccounted for. Courtesy of the Museum of New Mexico Press.*

Carlsbad Caverns *by Will Shuster, 1934. Works Progress Adminsitration Photograph Collection, Image 5500. Oil on "prestwood panel," approximately 72" x 48." Courtesy of the New Mexico State Records Center and Archives. This is one of four WPA paintings Shuster made in 1934 that are unaccounted for. Note the visitor trail visible in the foreground. The presence of this trail distinguished the 1934 series from his 1924 series of cavern paintings.*

Sensing the possibility of a larger collection, my research took me to remote West Virginia where, ten years later, I discovered the remnants of this art collection—13 black and white photos of this series printed between 1938 and 1941. I immediately embarked on a mission to bring these rare posters back into the public domain.

During the next ten years, several originals have turned up in addition to the one I found in 1973—Grand Canyon and Petrified Forest. Then five Mt. Rainier posters turned up in a garage in South Seattle—three "sandwiched" together in one frame! Later, Bandelier National Monument discovered more than a dozen—with complete documentation of their publication. In 2005 an anonymous collector called with two more original finds and returned to his source to acquire a nearly full set. The search continues….

Ranger Doug's Enterprises now republishes all fourteen original WPA National Park posters with two additional "See America" posters printed for the US Travel Bureau. Carlsbad Caverns National Park was featured as one of the posters in this series. He has also added several contemporary poster designs to this collection at the request of the parks: Devil's Tower, Bryce Canyon, Denali, Olympic, Mesa Verde and Hawaii, with more coming. All the posters are printed in the traditional serigraph manner. [19]

…the poster series equates national identity with a common history and geography by illustrating America's natural wonders as well as symbols of its economic and social culture, both past and present. This integration of the past and present in the "See America" series had a particular resonance in the context of the Depression. In an attempt to revitalize a culture fraught with economic hardship and instability, Americans sought and constructed a "usable past" that could unite Americans by recovering and affirming national values.

If not for the resourcefulness and determination of individuals like Leen, even more of the WPA's artwork would have disappeared forever, leaving a large blank area in America's understanding of its own history and culture in the 1930s and 1940s, when the country's identity was so closely linked to its art.

The National Parks Posters: Preserving a WPA Legacy

By 1938 the Federal Art Project (FAP) employed artists in all 48 states with a budget of 1% of the WPA's total budget and was clearly the largest single employer of artists in the United States. Between 1935 and 1943 over two million posters were printed by the WPA/FAP. These posters were based on 35,000 designs, of which only 2,000 actual posters survive today. Nearly 33,000 poster designs have been lost forever, representing 99.9% of America's public poster art from that time.

The early posters were individually hand painted in one or two colors and were produced in very limited editions, perhaps as few as 50. Poster subjects included art, theater, travel, education, health and safety. In 1934 Anthony Velonis joined the WPA/FAP and introduced the commercial technique of serigraph production. According to *Posters of the WPA* by Christopher DeNoon, in 1938 the WPA/FAP poster divisions had spread to at least eighteen states, with the Chicago poster unit producing 1500 posters per day. With the serigraph commercial process, posters with up to eight or more colors could be efficiently produced.

The National Parks Series posters were produced beginning in 1938 with the Grand Teton poster and ending in 1941 with the Bandelier National Monument poster. The artists and actual dates of production are unknown. The original posters, distributed to local Chambers of Commerce, were produced for internal marketing only and not for sale.[20]

This poster for Grand Teton National Park was the first of the Ranger Naturalist *series of WPA posters. Silkscreen, artist unknown, circa 1938. Courtesy of Ranger Doug's Enterprises.*

This poster for Bandelier National Monument was the last of the Ranger Naturalist *series of WPA posters. Silkscreen, artist unknown, circa 1941. Courtesy of Ranger Doug's Enterprises.*

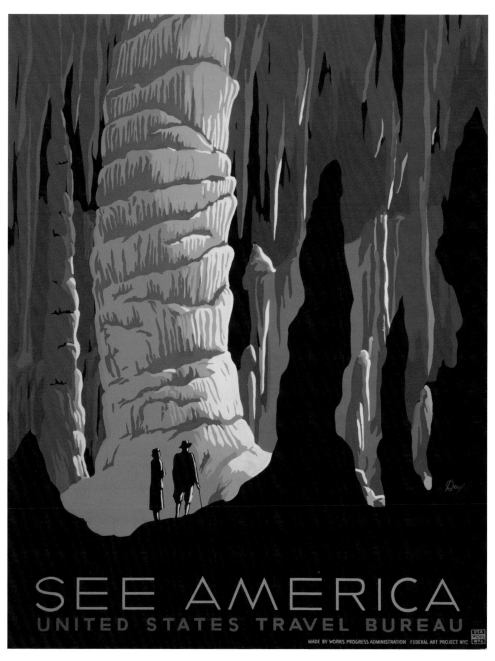

See America *poster for the United States Travel Bureau. Silkscreen based on original artwork by Alexander Dux, circa 1939, 28" x 22". Dux was one of the few WPA artists who were allowed to sign their work. Courtesy of Ranger Doug's Enterprises.*

Veiled Statue *1936 by Ansel Adams. 7"h x 4½"w. Courtesy of Carlsbad Caverns National Park.*

Chapter Four
A Struggle In The Dark:
Ansel Adams

"I am gradually becoming impressed with the Carlsbad Caverns; but they are so strange and deep in the earth that I can never feel about them as I do with things in the sun—rocks, trees…surf and fog. The photographic problems are terrific; I start with a basic exposure of about ten minutes (figured on the basic light provided by Mazda and the National Park Service). I then boost up the image and "drama" with photoflash. Some of the forms are beyond description for sheer beauty; textures and substance are not so important as the formations are white and cream-colored in the main.

Twice a day I ride down the elevator (just like an office building) for 750 feet, and then walk a mile through the caverns to the selected spot. I have not yet completed the smaller rooms—will tackle the Big Room (about two miles around) tomorrow and Friday."

Ansel Adams in a letter to Patsy English, December 2, 1936[1]

In addition to being one of the country's most talented photographers, Ansel Adams was also a prolific correspondent, writing letters in abundance to friends and family. Upon reading a compilation of his letters such as *Ansel Adams: Letters And Images 1916-1984*, a sense of Adams the man comes through clearly—passionate, irreverent, irascible, devoted, a lover of the natural world, of puns and the absurd. While Adams carefully removed from the subjects he photographed any taint of personal sentimentalism, he poured himself out to loved ones in the pages of his letters. They are a perfect complement to his photographs, giving a view of Adams' inner life and professional struggles in a way that his superlative photographs do not.

Photographing Carlsbad Caverns proved to be one of the greatest challenges of Adams' career. Stymied by the lack of natural light, long exposure times, and the kind of highly developed, recreational atmosphere that Adams disdained in national parks, he was not satisfied with the photographs he made there, and destroyed many of the prints.[2] Adams took pictures at the park twice: once in 1936 and again in 1941. Of Adams' first trip little is known,

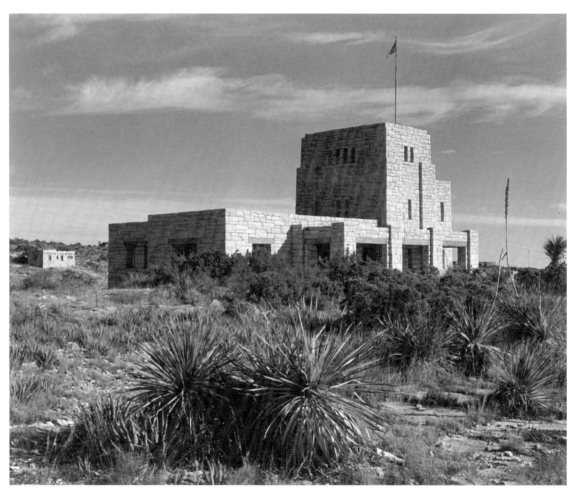

Carlsbad Elevator House, Distant View *1936 by Ansel Adams. 5½"h x 6⅞"w. This is one of three photographs showing the limestone building that originally housed the elevator that carried visitors into and out of the cave. The Natural Entrance trail is nearby. All three photographs are courtesy of Carlsbad Caverns National Park.*

except from his letters to various individuals like Patsy English (see above) and close friend and fellow photographer Alfred Stieglitz.

Superintendent Colonel Tom Boles, who complained about the burgeoning of amateur shutterbugs at the caverns in 1937, recognized the value of a professional photographer of Adams' caliber. In his Superintendent's Monthly Report dated December, 1936, he wrote the following:

> More Publicity: Mr. Ansel Adams of San Francisco, internationally known photographer, spent several days in this national park during the past month, and in my opinion has obtained some excellent negatives of the cavern formations, and inasmuch as Mr. Adams' photographs always occupy a prominent place in photographic exhibitions, I feel sure that his visit here will give this national park excellent publicity.[3]

Adams' second trip to the cave was part of a multi-park trek with the purpose of photographing national parks with a large-format camera. The photographs were to become mural-sized prints for the Department of Interior's Mural Project. He was given this assignment in 1941 by Secretary of the Interior Harold Ickes. Adams intended to make some thirty-six photographic murals to be installed at the Department of the Interior in Washington, D.C.

Adams hoped that his images would help positively influence political officials and promote protection of America's wild places. Unfortunately, World War II intervened, and the project was never completed. The holdings of the National Archives Still Picture Branch include 226 photographs taken for this project, including twenty-eight images from the Caverns.[4]

Twenty-five additional original signed prints survive from that 1936 trip. They were discovered in a file cabinet at the park around 1978 by Ronal Kerbo, who worked at the park for many years as its Cave Specialist, and went on to retire from the National Park Service as its National Cave Specialist in 2007.

Portrait of Colonel Thomas Boles, Superintendent of Carlsbad Caverns National Park, 1936. Photograph by Ansel Adams. Collection of the Center for Creative Photography, University of Arizona ©Trustees of the Ansel Adams Publishing Rights Trust.

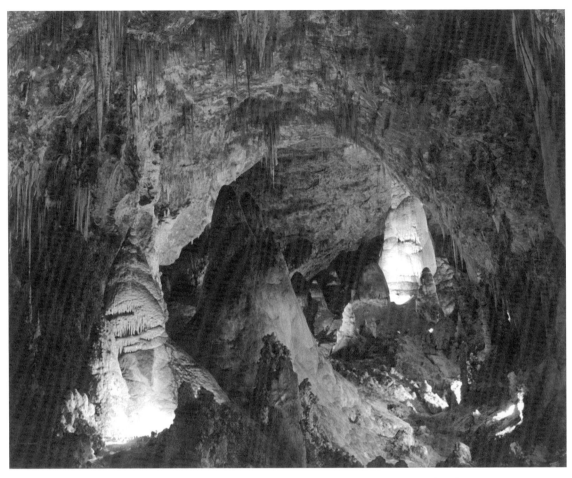

The Big Room *1936 by Ansel Adams. 5"h x 5¼"w. Courtesy of Carlsbad Caverns National Park.*

Kerbo recounts finding the prints: "When I first found them I was unsure what they were, but quickly saw that they were very important and as a joke took them to Jack Linahan, Carlsbad Cavern Area Manager (in those years Carlsbad and Guadalupe Mountains National Park shared a single superintendent, duty stationed in the city of Carlsbad), and told him I had found these old black and white prints. Jack glanced at them and then said 'So?' 'Well, so,' I said, 'can I have these? They were laying there and no one seems to care about them.' He said 'sure, or toss them!' I then explained who took the photos and that we needed to do something about preserving them. The prints were stuck in a manila folder with "Ansel Adams" written on the outside, and I seem to remember there may have been a date on

the folder. After that I turned them over to the park collections and really don't think I ever saw them again."[5]

Some of the prints were put on display for a short time as part of an exhibit entitled "A Cave Experience" during October and November of 1985, at the New Mexico Museum of Natural History in Albuquerque. After that, the prints were shipped to the Western Archaeological Conservation Center in Tucson Arizona, which serves as a repository for parks that lack adequate storage facilities for sensitive items and artifacts. The prints have been in storage there ever since.

A few of Ansel Adams' 1941 Carlsbad photographs have been reproduced in various books; in several instances, they were printed upside down. Those photographs were from the National Archives collection. The cavern images in this chapter are scans taken directly from the twenty-five original prints that Ron Kerbo discovered at the Caverns. It is the first time this collection has been published.

Ansel Adams: A Son's Perspective by Dr. Michael Adams

Ansel Adams and his wife Virginia had two children—a daughter, Anne, and a son named Michael. In 1941 Adams brought seven-year-old Michael with him on a photo trip that included Carlsbad Caverns National Park. Michael helped his father by carrying equipment and assisting with the lighting. According to Michael, "Traveling was fun. I was out of school on the trip to the Southwest. New and exciting places, interesting things to see and do and many new and old friends of the family. I don't remember any problems. Ansel was a good companion and interested in showing me exciting areas. I think he enjoyed the traveling just as much."

Michael recalled that shooting began in the morning, with the assistance of a park ranger who helped with the lighting and prevented visitors from getting into the shots. Based on a notation by Superintendent Boles in his monthly report, the ranger who assisted Adams was probably photographer Herbert Kennicott. "The only problems for Ansel were that all of the photography had to have additional lighting. Flash was used, with even some remote flash units connected by wire. I think he did not like working in the dark. I know he was much happier to be in the sunlight."[6]

Unfortunately, Michael came down with appendicitis after a couple of days, and spent almost a week recovering. He spent several days at the home of the local physician while Ansel completed his work at the caverns and then went on to shoot at the U. S. Potash Mine outside the city of Carlsbad. After leaving the Carlsbad area, Ansel, Michael, and long-time friend, photographer and violinist Cedric Wright traveled north toward Taos and immortalized the moon rising over a small church graveyard in the village of Hernandez.

Ansel Adams—Cave Photographer, by John C. Woods

Author's Note: I first met John Woods through my good friend, photographer Peter Jones. When I heard that John was a caver, a professional photographer, and had lived near Ansel Adams for many years, I was intrigued. When we met at Carlsbad Caverns in early 2008, I arranged to do a recorded interview with him, which has become part of the permanent historical record at Carlsbad Caverns National Park. John was very fond of Ansel, who he first met when he was just starting out as a professional photographer. "Ansel was the first person to buy one of my prints," remembered John. No doubt this was a powerful positive incentive for an aspiring photographer. I felt I could find no one better suited to write about Ansel's time as a cave photographer. His essay follows.

Ansel Adams with his son Michael, 1936. Photograph by Cedric Wright. Courtesy of Michael Adams.

Never interested in photography as a career, Michael went to Stanford University and then joined the U. S. Air Force as an Aviation Cadet. After completing pilot training he was sent to Japan and spent two years flying fighters. He entered medical school in 1963 and worked in Internal Medicine and as a pilot-physician until he retired in 1993. He is involved in the family business—the Ansel Adams Gallery at Yosemite National Park, California.[7] Michael also travels across the country speaking about Ansel Adams at museums and other institutions. In October of 2008, Michael returned to the caverns for the first time since visiting there with his father. He presented a program about Adams as part of the grand opening celebration for the park's new visitor center.

I have often said that there are only two photographers whom the average person remembers: Ansel Adams and the person who photographed their wedding. Very few know that the famed landscape photographer also photographed Carlsbad Caverns. Since I was both a cave explorer and a photographer, I was very interested in Adams' underground experiences. For years I lived only a mile from Adams' home in Carmel Highlands and on occasion, I would walk to his house and discuss it with him over tumblers of bourbon. This essay is based upon those talks.

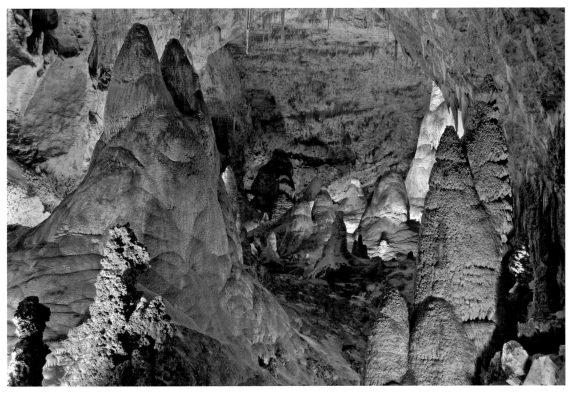

The Big Room—Carlsbad Caverns *by John Charles Woods, 2007. This photograph was taken from a perspective similar to the one used by Ansel Adams (see page 60). Courtesy of the artist.*

Most people accept the natural landscape as an appropriate subject for works of art, but caves are an utterly alien environment. Nothing is familiar and any sense of scale in a cave photograph depends upon the props or models that the photographer provides. Adams described Carlsbad Caverns as "…something that should not exist in relation to human beings. Something that is as remote as the galaxy, incomprehensible as a nightmare, and beautiful in spite of everything." [8]

Art historian Dr. Karen Klienfelder summed up the artistic approach that made it difficult for Adams to work underground. She said: "Most of Ansel Adams' works are about photographing transcendental light."[9] Adams was essentially an artist who reacted to natural light by making photographs. He had a talent for recognizing when the situation would translate well within the medium, but he could not necessarily create that lighting himself. His statement, "Sometimes I do get to places just when God's ready to have somebody click the shutter"[10] acknowledges his natural tendency. The total darkness of a cave however, precluded this approach. Unfortunately, his difficulty

in adapting to the underground situation was responsible for what he called his "unsuccessful" images of the cave. He admitted to me that it was one of the most frustrating photographic experiences of his life.

In a 1936 letter to fellow photographer Alfred Stieglitz, Adams described the commercial lighting in the cave as: "Something underground that was conceived in absolute darkness illuminated by electricity in the best Wagnerian Tradition." Adams literally hated the lighting and attempted a pun on the word "grotesque" "…the lighting is grottoesque" he continued, "darkness would be grateful." Adams admitted however, that he had no idea of how to proceed differently: "Things are seen (which never should be seen) in light consistently from the wrong direction (but I cannot think of any right direction). Can you imagine an illuminated stomach?"[11] Because the lighting along the visitor trail never varied in direction, intensity or color, Adams could not wait for whatever a constantly-changing natural light might reveal. As an accomplished commercial photographer he understood studio lighting, but it was not his normal route to creative imagery. Forced to use flash bulbs and other auxiliary light sources, he was entering an area that was not his preferred genre. The magnitude of the task was apparent to him and his letter to Stieglitz ends with an uncharacteristic plea: "This I must photograph—pray for me."[12]

Artistic and Technical Concerns

Although it may seem a strictly technical matter, Adams' choice of a view camera for the Carlsbad photographs was actually an artistic decision. A view camera is a large, tripod-mounted camera that exposes single sheets of film. A ground glass is used to focus and compose the image and a "dark cloth" draped over the camera shields the glass for viewing. Most

Ansel Adams in June of 1973. Photograph by John Charles Woods, courtesy of the artist.

of Adam's famed landscape images were made with view cameras that used films ranging from 4 x 5 inches to 8 x 10 inches in size. Each sheet of film could also be developed individually to suit specific lighting situations. Additionally, the harsh lighting conditions he would be faced with underground, forced the use of highly specialized developers and development techniques that were unsuited to roll films.

Adams' desire for maximum image quality made his decision to use the 5x7 inch Linhoff and Jewell view cameras inevitable, but it also

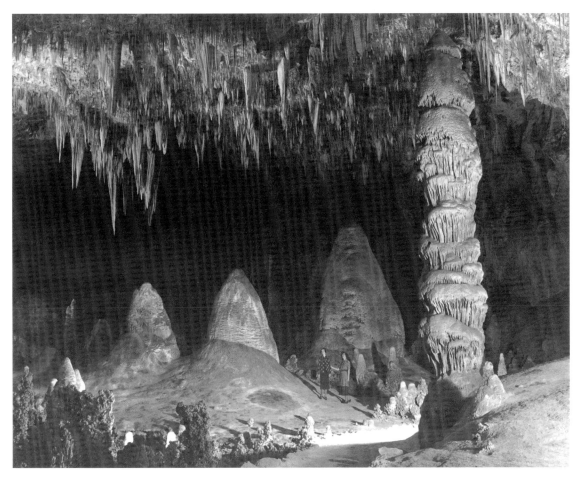

The Big Room *1936 by Ansel Adams. 5⅞"h x 7¼"w. In this image, one can clearly see the two models used by Adams to create a sense of scale. Courtesy of Carlsbad Caverns National Park.*

created a series of technical problems. Adams' goal was to create mural-sized prints for the National Park Service, and this was something that smaller film sizes could not produce. Primarily due to the view camera's immense film, no other camera of its time could produce better image quality in terms of tone and sharpness.

View cameras are inherently clumsy and slow to operate. It takes several minutes for the fastest photographer to set up the camera and expose a sheet of film. Even in bright sunlight, focusing and composing on a ground glass requires patience, precise control and a magnifier similar to a jeweler's loupe for critical focusing. In the dim commercial lighting of the Caverns, the problems of focus and composition were increased exponentially. There were physical demands also. With camera, lenses, tripod, film holders and lights in protective cases, the equipment weighed about 80 pounds.

The low light sensitivity of films in the 1930s and 1940s made cave photography in Carlsbad Caverns a difficult proposition even with the best equipment and expertise of the time. The most sensitive films of the period would be considered a medium to low sensitivity film by today's standards. Adams told me that his exposures ranged from the relatively short exposures of foil-filled flashbulbs (between 1/4 and 1/15 second), to several minutes' duration for some of the Big Room photos.

The long exposures created unexpected problems for Adams, and he was quick to discover that without a human being in the scene, the scale of the cave was lost. With such long exposures, the slightest movement of the model could blur an otherwise exceptional image. Adams responded to this dilemma with some unusual tactics. It is important to remember that Adams' Carlsbad photography was simultaneously a commercial job and an artistic endeavor. His goal was to make images that both satisfied his creative intent and suited the National Park Service's expectations.

When asked why he did not have more people in his photographs, Adams once quipped: "There are always two people in every picture: the photographer and the viewer."[13] Although clever, Adams' response doesn't apply to cave photography. Without known references, virtually all cave photographs dissolve into a chaos of overlapping forms. Even when natural shapes can be isolated for aesthetic effect, there is still no scale without something recognizable in the photograph. Viewers can become disoriented by space and size relationships that make no sense Experienced cave photographers recognize this problem and most cave photos include some form of reference; sometimes a descriptive caption will suffice. Adams usually celebrated nature without people in it, but the only way he felt he could make the cave recognizable was to use people as "props." "I was forced to intrude upon the scene with models." he said.[14] It was a great contradiction for him.

Despite his concerns about intruding upon the scene, Adams' photographs of Carlsbad have become an important part of the visual history of the National Park system. As works of art they may not have fulfilled Adams' artistic expectations, but they now serve a broader purpose. It is the nature of fame that it is self-perpetuating and the interest in Carlsbad Caverns that Adams' photographs have generated ultimately reinforced Adams' great love: the preservation of earth's natural wonders. This is a fitting epitaph.

Queen's Chamber Draperies *1936 by Ansel Adams. 7⅞"h x 5½"w. Courtesy of Carlsbad Caverns National Park.*

Detail of Draperies In The Queen's Chamber *1936 by Ansel Adams. 7¼"h x 5¼"w. Courtesy of Carlsbad Caverns National Park.*

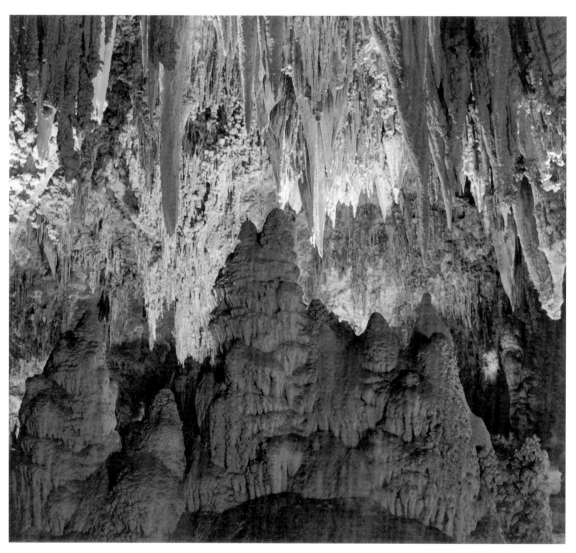

The King's Palace *1936 by Ansel Adams. 5¾"h x 6¼"w. Courtesy of Carlsbad Caverns National Park.*

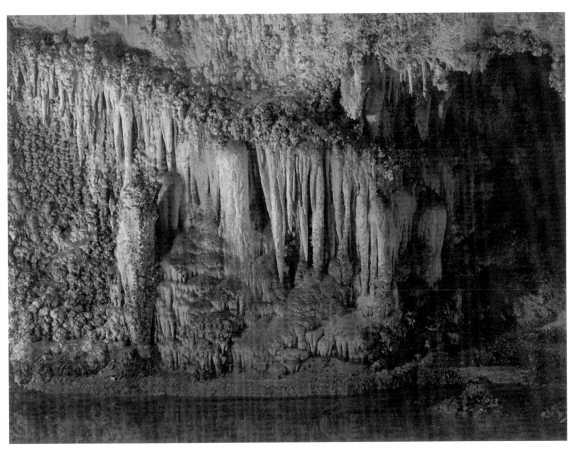

Carlsbad Formations, Detail *1936 by Ansel Adams. 5⅜"h x 7⅛"w. Without a human figure to give a sense of scale, cave photographs can be difficult to interpret by the average viewer. This is a close-up view of a small section of wall formations above a pool. Courtesy of Carlsbad Caverns National Park.*

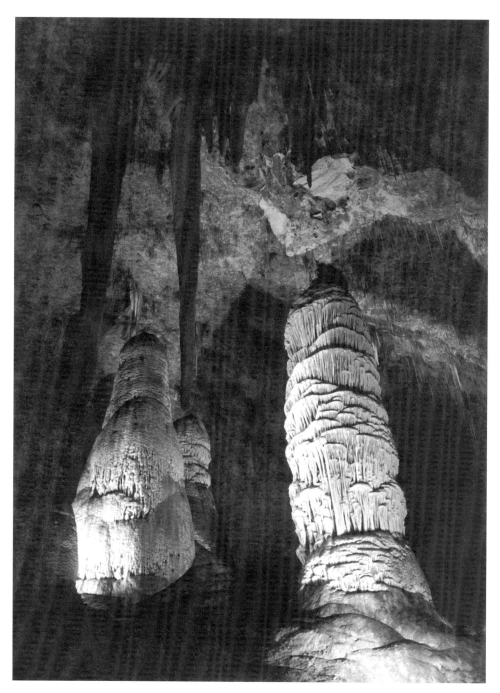

Giant Domes *1936 by Ansel Adams. 7¼"h x 5¼"w. Courtesy of Carlsbad Caverns National Park.*

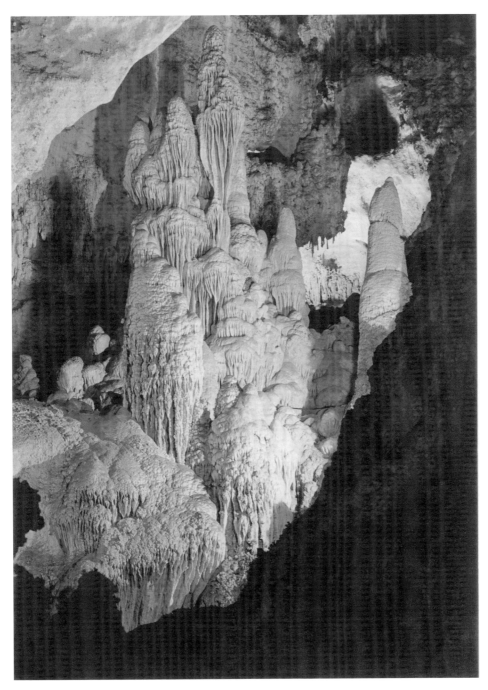

The balcony by the Green Lake Room *1936 by Ansel Adams. 7¼"h x 5¼"w. Courtesy of Carlsbad Caverns National Park.*

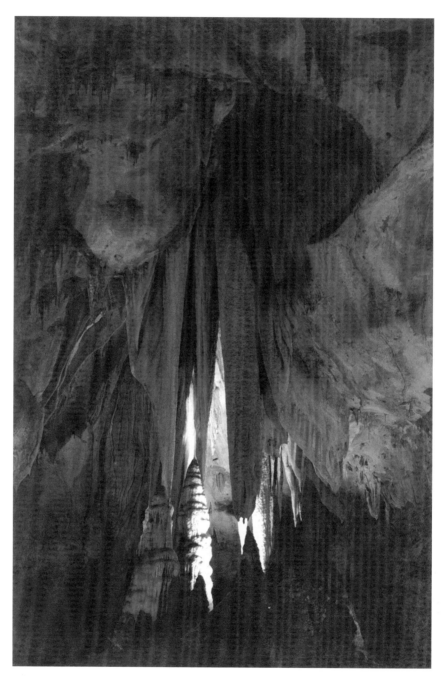

Papoose Room *1936 by Ansel Adams. 7¼"h x 4¾"w. Courtesy of Carlsbad Caverns National Park.*

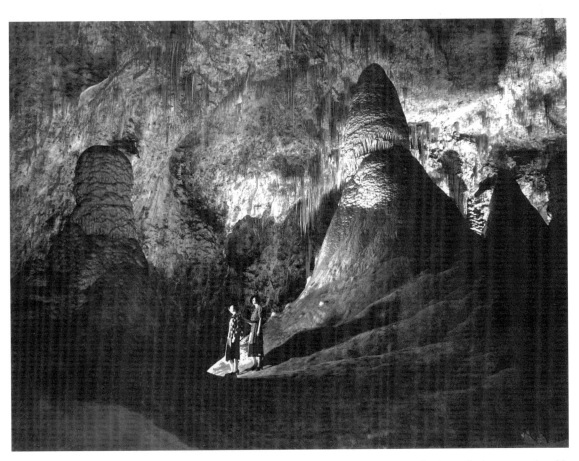

The Big Room *1936 by Ansel Adams. 6⅞"h x 9⅛"w. Exposure times running into several minutes for large room shots like this one no doubt tried the patience of his models. Courtesy of Carlsbad Caverns National Park.*

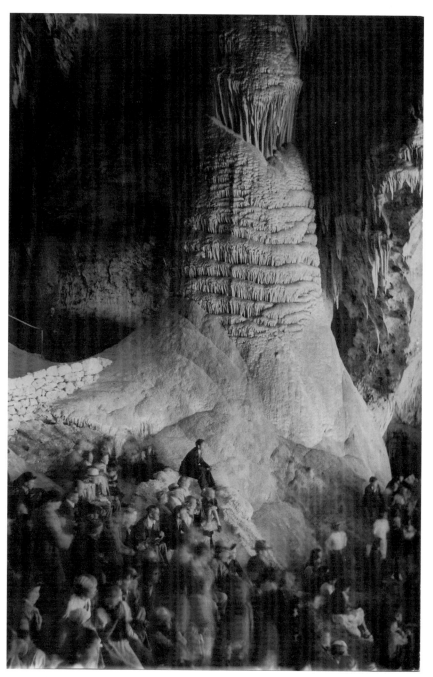

Visitors gather for a presentation below the Rock of Ages. *Photographer and date unknown. Courtesy Carlsbad Caverns National Park.*

Chapter Five
Portrait of a National Park

It could be said that the downfall of Superintendent Tom Boles was cuased by a song. Beginning in July of 1927, the first Rock of Ages ceremony was conducted at Carlsbad Caverns. The spectacle commenced with a talk by Superintendent Boles and was presented to a group of visitors gathered at the base of the Rock of Ages, one of the largest stalagmites in the cave. The lights went out, plunging the visitors into total darkness. Renowned baritone Cameron McClean then sang the hymn "Rock of Ages."[1] At the song's conclusion, visitors continued their tour through the cave.

One visitor recounted her experience of the ceremony in 1936:

> The lights were extinguished and after 30 seconds of absolute darkness a clear tenor voice, from a ranger 600 feet away, sang *Rock of Ages*. The lights came on one by one until the entire Big Room was again flooded but we remained in spellbound silence. For most of us this was a moment of rapture when our souls were merged with the Soul of All Things. As we quietly got to our feet and resumed our journey I overheard a 12-year-old boy whisper, "Mother, I'm going to be a better boy."[2]

The ceremony continued to be a popular attraction for seventeen years until it was discontinued in December of 1944. Apparently, National Park Service Director Newton Drury didn't think it was dignified enough to be a National Park Service presentation. After Boles ignored several orders to stop the program, NPS higher-ups officially terminated it. There are some who believe that Boles' transfer to Hot Springs National Park in 1946 was a consequence of his refusal to follow orders (this was not the first time NPS managers had encountered Boles' recalcitrant streak). The cancellation of the ceremony was the most common complaint from visitors for the next decade.[3]

Hal K. Rothman's excellent book, *Promise Beheld and the Limits of Place: A Historic Resource Study of Carlsbad Caverns and Guadalupe Mountains National Parks and the Surrounding Areas* rises above its cumbersome title with valuable insights into the workings of the National Park Service during its formative years. Rothman writes:

> To the many who protested the end of the Rock of Ages ceremony, the event, not the cavern itself, was the most powerful memory of their experience. The ceremony made their trip special. Here was meaning and significance, emotion and feeling rolled into one. Here was nature subordinate to human imagination and manipulation, a wondrous place made significant not by a sophisticated and discrete template as in faux historic communities such as Santa Fe, New Mexico, but by brazen and direct orchestration that appealed to the most meaningful and at the same time most contrived emotions Americans possessed. The Rock of Ages possessed a poignancy that moved people, especially during World War II. It provided solemn testimony that there was a spiritual dimension to life at a time when temporal concerns dominated everything.[4]

Though National Park Service officials may have been uncomfortable with the nature of Colonel Boles' ceremony, visitors obviously appreciated the opportunity it offered them to process their own emotional responses to the grandeur of the cave. After spending many hours walking through such a vast, alien environment, it was probably a great relief to hear this familiar hymn sung by a human voice. The interior of a cave is so foreign to most visitors that they find themselves unable to grasp all of the visual input they receive. This may be one reason explorers have named cave formations after recognizable objects since the earliest years of the Cavern's history: bacon, draperies, soda straws, The Bashful Elephant, and so on. More than one visitor has commented that what they remembered most clearly about their trip to the cave was the Underground Lunchroom—an area that looks like a café that was transplanted *in toto* from the surface into its grotto 750 feet underground.

To Portray The Impossible

The art collection at Carlsbad Caverns National Park contains the results of artists attempting to codify their perception of the cave. Due to the challenges of accessibility, only a handful of artists and photographers attempted to portray the caverns before 1940. Though ease of access improved greatly and photography became increasingly popular as a means of capturing the cave's likeness, artists working in other media remained scarce at the park. This was at least partly due to the regimented type of tour experience offered from the 1930s through the 1950s, during the

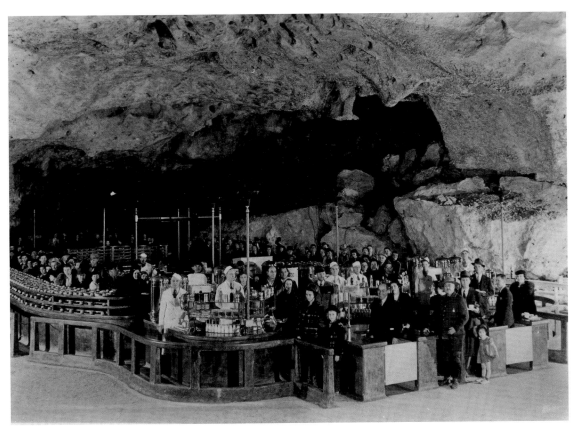

The Underground Lunchroom, *750 feet below the surface. NPS photo.*

heyday of the cave's popularity. Thousands of visitors required intense supervision, and the lights in the cave were turned off in between groups to save energy and thwart the growth of algae. This was not conducive to an artist who needed time to reflect and work quietly without interruption.

Fortunately, a few did persevere, and some gave samples of their work to the park. Other cave-related artwork occasionally can be found for sale online or in galleries. Some of the best existing examples of artwork inspired by Carlsbad Caverns, however, can be found in the extensive promotional material produced by the railroads and other entities in an attempt to entice Americans to visit this somewhat remote destination.

Temple of the Sun *by Don M. Black. Oil on canvas, 45"h x 37"w. The date is 1958. It was transferred from Grand Canyon National Park to Carlsbad Caverns in 1979. Courtesy of Carlsbad Caverns National Park.*

This painting of the Big Room by R. Cormer is oil on a poorly prepared wood panel 15"h x 20"w (date unknown). It was probably a gift to the park, given by a ranger who worked there or by a visitor. The painting's primitive style indicates that it was not created by a professionally trained artist, though it shows a carefully considered approach to the various textures found in the cave's formations. Courtesy of Carlsbad Caverns National Park.

All Aboard! The Train Comes To Carlsbad

The phenomenon of tourism by train evolved hand-in-hand with the concept of the national park system. It could be argued, in fact, that the momentum of the railroads provided impetus for establishment of the parks. Author Joshua Scott Johns wrote, "from the earliest days of discovery to the crucial National Park Act of 1916, the process of park development was shaped by needs of the railroads—from acquiring investors to selling mass-market tourism, they modified their advertising strategies to win the patronage of new passengers with the promise of fulfilling their expectations of the West in "America's playgrounds."[5] Though Johns was writing primarily about Yosemite and Yellowstone National Parks, this trend extended across the country and affected most large parks to one degree or another. Carlsbad Caverns was no exception.

Two great railroad lines promoted the Caverns as a destination: The Southern Pacific and, more significantly, the Atchison Topeka & Santa Fe Railway (simply known as the "Santa Fe"). The Santa Fe launched an aggressive campaign to promote tourism to Carlsbad Caverns via its "Peavine Branch" stretching along

the Pecos River valley. Posters, magazine ads, and multi-page booklets describing the cave's wonders were printed. In 1940, only $9.75 paid for round-trip train travel from Clovis to Carlsbad, motorcar service from Carlsbad to the Caverns and back, entrance fee to the cave, guide service, and a meal in the Under-

ground Lunchroom, plus breakfast and dinner at a Carlsbad hotel. The twenty-five-cent fee to ride the elevator out of the cave was not covered, however.[6]

Marketing hyperbole ensnared the imaginations of Americans, promising an exciting, even transformational experience, as described in this Santa Fe Railroad promotional booklet:

> By now, our old life above ground has become as vague and formless as the memory of some former existence. Time, distance and direction are forgotten. An overwhelming sense of the vastness, the sublimity, the unearthliness of our surroundings struggles vainly for expression. The constantly shifting display runs ahead of the imagination and a consuming curiosity prompts a thousand questions. We already take it for granted that light will reveal the unexpected and impossible behind every shadow in the clean, cool night of this buried world.[7]

The Santa Fe Railroad claimed to be "the only railroad to Carlsbad Caverns National Park." Promotional posters like this were produced around 1950. The poster is 36"h x 24"w. Photographer unknown. Courtesy of Poster Plus, www.posterplus.com.

The Southern Pacific Railroad also utilized Carlsbad Caverns in its advertising. This is interesting in light of a notation by Colonel Boles in his Superintendent's Report from February 1935, in which he stated that the Southern Pacific ran advertisements in *Esquire*, *Time*, and other magazines despite the fact that the

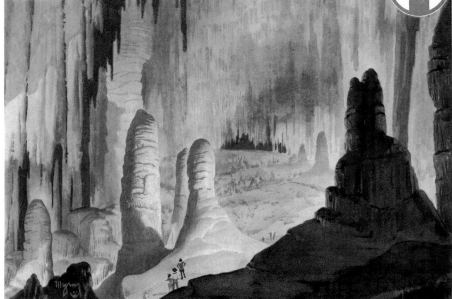

Santa Fe is the only railroad to Carlsbad for Carlsbad Caverns National Park.

Daily Pullman service direct to Carlsbad, New Mexico, from Chicago and Los Angeles

Carlsbad Caverns, in the Guadalupe Mountains of southeastern New Mexico, rank with the Grand Canyon as one of the two or three great natural wonders of the world.

But like trying to describe the Grand Canyon, it is impossible to picture in words the silent grandeur of Carlsbad Caverns—where sunlight has never reached since the dawn of time.

Formations frozen in stone

Fantastic formations frozen in stone, such as Rock of Ages, Chinese Temple, and Lady at the Organ, meet the eye at every turn.

The ceiling has disappeared under millions of stalactite pendants. Grotesque stalagmites, weighing many tons each, rise from the floor.

And the tremendous size of this underground fairyland (temperature, 56° the year 'round) is almost unbelievable.

For instance, the "Big Room" alone is 4,500 feet long, 625 feet wide, 300 feet from floor to ceiling. No photograph yet taken reveals more than an infinitesimal part of its glories.

The way to see it

Plan to visit Carlsbad Caverns via Santa Fe this fall or winter, so you can enjoy an unhurried exploration of *all* parts of the floodlighted Caverns open to the public. U. S. National Park Rangers will be your guides.

Santa Fe provides daily Pullman service from both Chicago and Los Angeles direct to

Carlsbad, New Mexico, where motor coaches meet the train for the 27-mile ride to and from the entrance to the Caverns.

Let us send you an illustrated brochure that gives full details on how conveniently you can include this world-famous underground fairyland in your trip to or from California via Santa Fe. Just mail the coupon.

R. T. Anderson, General Passenger Traffic Manager
Dept. L-3, 80 East Jackson Boulevard
Chicago 4, Illinois
Please send me your illustrated brochure, "Carlsbad
Caverns," and tell me how easily I can visit this won-
derland on my next trip to or from California.

Name_____

Address_____

City_____State_____

SANTA FE SYSTEM LINES . . . Serving the West and Southwest
R. T. Anderson, General Passenger Traffic Manager, Chicago 4

This promotional ad for the Santa Fe Railroad featuring Carlsbad Caverns National Park ran in various magazines in 1948. The size is 13½"h x 10"w. Courtesy of Carlsbad Caverns National Park.

This poster was produced by the Southern Pacific Railroad around 1945. The artist was Willard R. Car. The poster measures 23"h x 16"w, and depicts a group of visitors with a ranger, all of whom are dwarfed by the monumental scenery of the cave. Courtesy of Carlsbad Caverns National Park.

The Coca-Cola Company ran this ad in The Saturday Evening Post *in July of 1931. Visitation at the park during this time averaged 90,000 visitors a year, not nine million a day. Courtesy Carlsbad Caverns National Park*

railroad did not come within 160 miles of the park at that time.[8]

With the advent of the automobile and its rise as the preferred mode of transportation for Americans, the symbiotic relationship between national parks and the railroads was sundered forever. Railroad development began to decline sharply after peaking around World War I. The Federal Government began to redirect funds—previously earmarked to build track and purchase land for railroads—into construction of millions of miles of highway.[9] Of the indelible mark left by the railroads, Joshua Scott Johns wrote, "The railroads could not have imagined their rapid downfall after the automobile's ascent, but their persistence in acquiring and protecting national park lands and the images they implanted in the national consciousness left a legacy that transcends their economic motivations."[10]

The railroads were not the only companies to recognize the value of Carlsbad Caverns as a vehicle for reaching popular culture. The Coca-Cola Company, which began in 1886, featured the Caverns in its "Pause That Refreshes" advertising campaign, which emphasized scenes that showed Americans enjoying a relaxing interlude while drinking Coca-Cola.[11] The July 11, 1931 issue of *The Saturday Evening Post* shows a full-page ad with visitors 750 feet underground, enjoying the national soft drink. The text reads, "Weary from the long trail, all give hearty welcome to a familiar and delightful custom—*the pause that refreshes.* Over nine million a day come up smiling and off to a fresh start after a short rest period with ice-cold Coca-Cola. So can you."[12] Considering the fact that visitation around 1931 was in the vicinity of 90,000 per year, this advertisement is a bit of an exaggeration. But when did an advertising agency ever worry about an extra "zero" here or there? Visitors were no doubt thrilled to be able to have a cold drink during this time before elevators were installed in the cave, necessitating a long descent an even longer climb out of the cave. The round-trip journey covered about six miles.

2,400 Flashbulbs: The Big Room Shot by Tex Helm

In 1951 a technological revolution was taking place in the photographic world, and Sylvania Electric Products needed to find an edge in the marketplace for its new Superflash bulbs. Designed to replace flash powder and magnesium ribbon and their noxious vapors, these bulbs were roughly the size of a standard 100-watt light bulb, with the same type of threaded base. Each bulb contained a clump of magnesium filaments. When the filaments were ignited by an electrical charge, the bulb prevented smoke and fumes from escaping into the air.[13]

Though they were a huge improvement over earlier methods of photographic light production, flash bulbs were slow to catch on, partial-

ly because they were expensive and extremely fragile. It's no wonder then, that Sylvania enthusiastically donated 2,400 of its Superflash bulbs for a colossal photographic first: Ennis Creed "Tex" Helm's plan to photograph—in one shot—the entire Big Room of Carlsbad Caverns, a chamber roughly 600 feet wide and half a mile long, with 180-foot-high ceilings. Considering the relatively low sensitivity of color film at the time, this was an almost impossible task. Each Superflash bulb produced light equivalent to 1,290 sixty-watt household bulbs, but it was still unclear whether or not they were up to the challenge of lighting such a vast space.[14]

Tex Helm (1903-1982) had first explored the Caverns while working for the *Fort Worth Star-Telegram* in 1924. Almost thirty years later, technology had finally advanced far enough to enable him to realize his dream and attempt this record-setting photograph. On August 19, 1952, Helm and a crew of assistants from Southwestern Public Service, a power company, laid three miles of copper wire and placed fifty aluminum reflectors, scores of flexible foil reflectors, and thirteen cameras (mounted on boards balanced between two stepladders) in preparation for the shot. One hundred and fifty Carlsbad residents took their places throughout the Big Room.[15] *National Geographic* writer Mason Sutherland was present, and described the event for the magazine:

As the park's floodlights were turned off, plunging the cave into darkness, Helm mounted a stepladder and opened the shutters. He had to memorize the position of every camera so as not to tip it out of line.

When Helm gave the command, "One, two, three, fire!" hundreds of bulbs crackled. Light, as startling as lightning, bathed the caverns in a blinding, crucible glow for one-thirtieth of a second. When darkness reigned again, Helm closed the shutters.[16]

The shot was a huge success, and was first published as a two-page spread in the October, 1953 issue of *The National Geographic Maga-*

Here Tex Helm prepares the thirteen cameras he synchronized to photograph the Big Room. Each camera was set to a different aperture to allow for errors in calculation of the light generated by 2,400 flash bulbs. NPS photo.

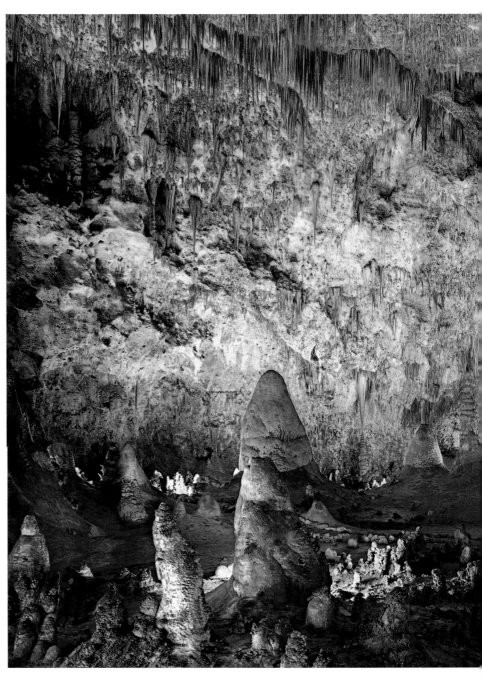

Distant Rock of Ages and Other Stalagmites Stand Out Like Icebergs in a Colored Sea. *So vast is the Big Room and so twisting the trail that most visitors fail to recognize it as a single chamber.*

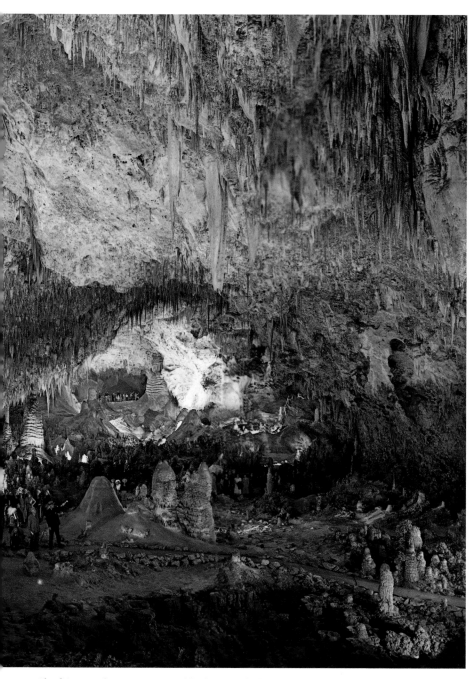

Chief Sunny Skies Hunt, a Carlsbad Curio dealer, stands in center in his Indian headdress. Photograph by Tex Helm, 1952. Courtesy of Carlsbad Caverns National Park.

Photographer Tex Helm (second from right) poses with his assistants and 2,400 spent flash bulbs after the Big Room shot was completed. Photographer unknown, NPS photo.

zine. Sylvania, thrilled by this much-desired publicity, donated an additional 14,000 bulbs to Helm for other projects. The general public was still slow to accept the new technology; flashbulbs did not overtake flash powder once and for all until the late 1950s.[17] Posters of the Big Room Shot are still sold at the Caverns Visitor Center bookstore and the image is no less impressive than it must have been in 1953. One existing original print is in the collection of the park; another is in the collection of the Carlsbad Museum, which houses Tex Helm's papers and personal effects. Sadly, both prints have sustained damage over the years. Photoshop was used to repair the damage and re-correct the color of the slightly faded print reproduced in this book.

East Meets West: Toshi Yoshida

Historically, most visitors to America's national parks have been white individuals of European descent. Many elements contribute to this continuing fact. Ethnic groups tend to inhabit urban areas and are thus less likely to seek wild areas for recreation. The "See America" promotional poster series that began in the 1930s established the concept of national parks as playgrounds for white Americans. In her article *See America: WPA Posters and the Mapping of a New Deal Democracy*, author Corey Pillen describes how:

> The whiteness of the "See America" series, however, reveals itself not only in its nostalgia for a pre-industrial past but also in the racialized landscape it depicts. African and Native Americans in the "See America" series were meant to provide tourists with a glimpse of local color…Moreover, by representing them as objects to be consumed but never as consumers, the series distanced Native and African Americans from an important means of asserting and reaffirming cultural citizenship during the Depression era.[18]

According to Roger Rivera, founder of the National Hispanic Environmental Council, national parks have an elitist reputation in many nonwhite communities, where people

Japanese woodblock artist Toshi Yoshida circa 1954. Photograph by Takashi Yoshida, courtesy of the artist.

have had limited or no exposure to the park system or to park rangers. "There's an interesting notion out there that public lands and protected areas have been the domain of middle-class whites," he said.[19] The National Park Service has been working hard in recent years to balance cultural diversity in the parks and in

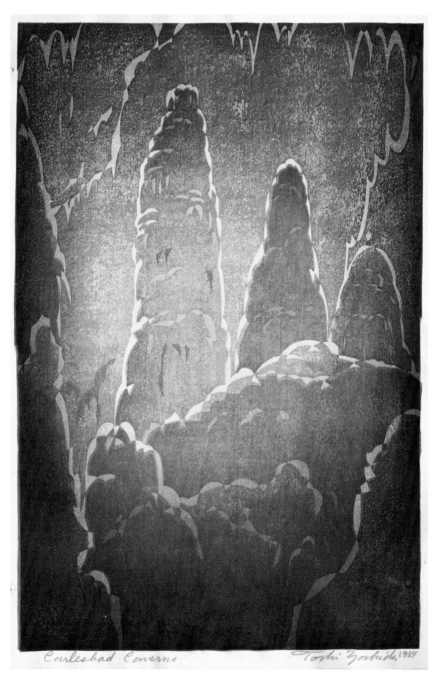

Carlsbad Caverns *woodblock print by Toshi Yoshida, 1954. Signed in pencil by the artist. 14⅛"h x 9⅞"w. Courtesy of Carlsbad Caverns National Park.*

its workforce. Today many park units interpret the cultural importance of that site, or represent the story of a particular ethnic group in America.

Fortunately, it is difficult to deter an artist intent on capturing impressions from a specific place. When Japanese woodblock print artist Toshi Yoshida (1911-1995) visited Carlsbad Caverns in 1954, it is doubtful that he considered his trip to be a landmark event. However, he did create the only known woodblock print of the cave by a Japanese artist of his caliber. A third-generation artist, Yoshida was taught woodblock printing by his father, Hiroshi, himself a master printer and painter. Toshi's mother, Fujio, was also an artist. After World War II, Toshi Yoshida left Japan and began to travel the world, including Antarctica.[20]

An outdoor enthusiast and mountaineer, Yoshida created many landscapes. After the death of his father in 1950, he began to experiment with abstraction. Much of his work from this period alludes to natural forms, and the surreal formations of Carlsbad Caverns must have seemed like the perfect combination of realism and abstraction in a natural setting. The muted browns and tans of the print entitled "Carlsbad Caverns" are consistent with the limited palettes of his other abstract work from that time.

Today Yoshida prints are highly sought-after by collectors. His work appears in the collections of the Museum of Modern Art in New York, the Boston Museum of Fine Arts, and the British Museum, to name a few. The Carlsbad Caverns print was purchased by the Cavern Arts Project and was donated to the park for its permanent collection.

A New Age of Exploration

It would appear that Carlsbad Caverns had been thoroughly domesticated by all the infrastructure required to turn a wild cave into a National Park, but the Caverns still contained secrets. Despite more than thirty years of exploration by curious visitors and serious cavers alike, significant new areas were discovered during the 1960s. Several waves of survey and mapping have been done at Carlsbad Caverns since the 1930s. Over time, as survey techniques improve, existing maps of the cave become obsolete and are redone with more accuracy and better data. In the 1960s members from two national caving organizations were instrumental in adding new mileage to the map at Carlsbad Caverns.

The Cave Research Foundation initially focused on mapping Mammoth Cave in Kentucky starting in the late 1940s. Over time the group began to work in Carlsbad Caverns National Park and other areas. The National Speleological Society, based in Huntsville, Alabama, was founded in 1941 and is the world's largest caving organization. NSS and CRF members have worked as volunteers at the cave for decades, exploring, mapping, photograph-

ing and performing scientific research and conservation projects for the National Park Service.

Photographs taken by members of these groups during their expeditions expanded the visual scope of the Caverns. Improvements in film speeds, lighting, and lenses enabled cavers to capture aspects of the cave's formations in ways that were not possible for earlier photographers. Cavers entered delicate, virgin passages that had not yet been trampled by the feet of thousands of curious visitors. The sights they captured on film give a glimpse of what the first explorers into Carlsbad must have seen.

Dr. William R. Halliday, world-renowned speleologist, author of many books about caves, and co-author of the book *Carlsbad Caverns, The Early Years: A Photographic History of the Cave and Its People*, took the photographs on page 93. Halliday writes,

> In those days I always used a spot beam flashlight to plan the shadows in my photos, and either an open flash with an old strobe or a long exposure like 1/2 second + strobe, using an Exakta VX. That was 51 years ago.
> As for me, I've been a caver 62 years but had to retire from active caving at age 80, a coupla years ago. Ever since I was first there, in 1940 when I was able to listen to Jim White spin tales at his little sales booth, I've considered Carls-

bad the greatest cave, and have said so in various books. And I've seen something like 2,000 caves in many parts of the world—I lost count in China.[21]

On June 26, 1966, a huge new chamber, second in size only to the Big Room, was discovered. The Guadalupe Room is almost an hour's worth of tortuous crawling, climbing and squirming travel from the visitor trail in the Main Corridor. Its remoteness kept it hidden from earlier explorers; only the tenacity of cavers—who often return repeatedly to areas in search of unexplored leads—resulted in its discovery. The Guadalupe Room contains active pools, flowstone cascades, and bright yellow formations. Due to its relative inaccessibility and delicacy, this area of the cave will never be opened to tourism. The photographs taken by cavers are particularly important, as they are the only way interested visitors can enjoy the marvels of this special chamber.

Terry Marshall, Carlsbad resident and author of many books and articles about the area, wrote this description of traveling off trail in the cave. However, the challenging ranger-guided trip he was on (yes, the rangers will actually take visitors on a real caving trip to the Hall of the White Giant) covered just a portion of the route to the Guadalupe Room.

> Wearing hardhat and headlamp, we slip off the paved trail inside the Cavern

and worm our way into a maze of helter-skelter holes in the jumbled rock. Inside it's breezeless, dry, and warm. Then comes subterranean mountain-climbing: hiking narrow, winding trails; inching along a cliff side; negotiating crevices; clambering over man-sized rocks, up slippery chutes and slopes; crawling through tight fissures, then snake-like, squirming through tiny openings. The adventure climaxes at a scenic overlook of a mountain valley of upside down ghost trees, guarded by the White Giant, a huge stalagmite.

A photograph of delicate and rare helictite formations in the Left Hand Tunnel area of Carlsbad Caverns. This area is far from the visitor trail. Photo by Dr. William R. Halliday, 1957. Courtesy of Carlsbad Caverns National Park.

The trek leaves us puffing. It's not for the claustrophobic.[22]

"The Following Year, They were Wiped Out"

Historic photographs also serve a bittersweet function: they document features of the Caverns that have been lost forever. Long-time caver and photographer Pete Lindsley was a founding member of the Guadalupe Cave Survey, which discovered and mapped large areas of the cave that were discovered in the mid-1960s (it later merged with the Cave Research Foundation). He captured the ethereal delicacy of aragonite crystals in the photograph below. That photograph, Lindsley recalls, was taken "a month after our discovery of the Guadalupe Room, and the following year they were wiped out [by another group]...So much for cave conservation."[23] The double-edged sword of exploration versus impact is unavoidable, and causes great debate among cavers and cave managers alike.

Conservation ethics and practices have evolved dramatically since the early days when visitors inadvertently did incredible damage to delicate, formation-covered floors simply by walking across them. Today cavers are careful to wear boots with non-marking soles and to walk only in areas that have sustained previous impact in order to minimize evidence of their visits. "Cave Softly" is the mantra of any seasoned caver.

Improvements in lighting, lenses and film allowed later photographers to capture the extraordinary delicacy of the cave's smaller formations. Here, fingertips give a sense of scale to a cluster of aragonite crystals found on the way to the Guadalupe Room. One clumsy movement would crush these crystals into oblivion. Photograph by Pete Lindsley, 1966. Courtesy of Carlsbad Caverns National Park.

Chapter Six
Finding A Place in the Mainstream

In the 1960s and 1970s, Carlsbad Caverns National Park seemed to be searching for a new identity. Tourism patterns in America were changing as the speed and efficiency of interstate highway travel eclipsed the more leisurely, scenic pace of smaller highways like Route 66. As a result, the National Park Service had to take additional measures to keep remote parks like Carlsbad Caverns in the forefront of American awareness regarding recreation.

Author Hal Rothman describes the shift in this way:

> The same sorts of technological in-novations that made Carlsbad Caverns more accessible drew the attention of younger Americans away from the caverns. By the 1970s, when movies boasted a range of incredible adven-tures from *Planet of the Apes* to *2001: A Space Odyssey* and television shows such as *Lost in Space* offered a vision of the future that could—and should—exist

for Americans, the magic of Carlsbad Caverns seemed lost on an increas-ingly sedentary, urban public that mainly traveled by interstate highways. A walk through the caverns seemed dated; television and movies routinely showed more spectacular scenes. To a culture that increasingly had difficulty differentiating between the "real" and the contrived, the experience of being underground among even the most spectacular natural formations had considerably less cachet and somehow seemed less impressive than it had a generation before.[1]

Early Cinematography at the Caverns

Carlsbad Caverns is no stranger to publicity, and the progression from still photography to film was a natural one. With its dramatic forms and vast spaces, Carlsbad is a perfect subject

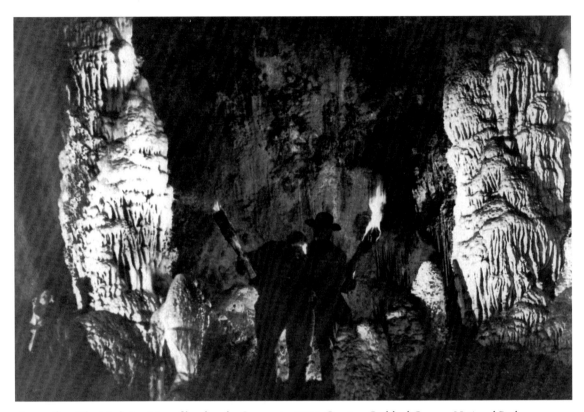

A scene from The Medicine Man, *filmed at the Caverns in 1929. Courtesy Carlsbad Caverns National Park.*

for the bright lights used by cinematographers. As early as 1924, Fox Motion Picture Company filmed news and feature segments during a *National Geographic*-sponsored expedition. *The Medicine Man* was the first feature-length film with scenes shot in the Caverns, with additional scenes along the Pecos River valley. This cowboy movie was filmed in 1929 by Jack Irvin Productions.

Carlsbad Caverns turned out to be a perfect setting for plots that took advantage of archetypes associated with caves: secrecy, danger, the unknown, mystery and adventure. The first high-profile film made at the cave was *Journey to the Center of the Earth* in 1959. According to retired park historian Bob Hoff, the completed film by 20th Century Fox contains about eleven minutes of footage that were shot in the King's Palace, the Boneyard, and near Appetite Hill. His excellent list of commercial filming at Carlsbad Caverns between 1924 and 1993 can be found on his Retired Park Historian's online site.[2]

In his excellent guide to travel in New Mexico, author Dave DeWitt recorded this interesting anecdote:

In the late 1920s, the Caverns were scouted as a possible location for Hell by filmmaker Henry Otto, who was making the movie *Dante's Inferno* for the Fox Film Company. Unable to find a suitable location in California realistic enough to "satisfy the fundamentalists," Otto toured Carlsbad Caverns but came away disappointed. According to one witness, "One look at the vast interior of the cave convinced Mr. Otto that here was no place to shoot the *Inferno*. This didn't look anything like Hell. Why, if he made his film in this fairyland, it would be nothing less than a clever bit of propaganda for Hades, and everybody would want to go there."[3]

Due to the rigorous protection of copyrighted material by studios like 20th Century Fox Films, it was not possible for me to use some of the great film stills from the park's collection. Instead, I have used stills from old movies that are no longer commercially available, and shots of the production sets taken by NPS staff.

"Ranger, There's a Gargoyle in my Cave"

As an interesting by-product of the same trend that threatened to nudge Carlsbad Caverns into obscurity, film projects at the Caverns multiplied from a handful in previous decades to more than a dozen during the 1970s alone. These productions ran the gamut from edu-

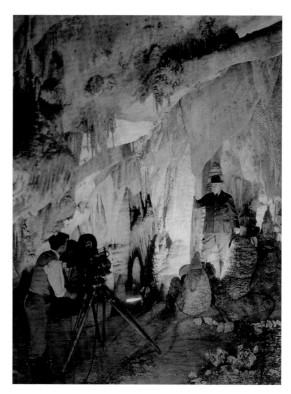

The relationship between Hollywood and Carlsbad Caverns has been longstanding. Always willing to go the extra mile to promote his park, Superintendent Boles is shown here being filmed by L.E. Orr for Fox Movietone in 1931. Courtesy Carlsbad Caverns National Park.

cational video projects to TV commercials to feature-length Hollywood films. In 1972 CBS-TV filmed portions of the movie *The Gargoyles* (starring Cornel Wilde with Bernie Casey as the lead monster) in the Caverns, primarily in the Left-Hand Tunnel area at the back of the Underground Lunchroom.

In what must have been one of the more dubious decisions regarding resource protection

ever made at Carlsbad Caverns National Park, permission was given to Hall Bartlett Productions and JLS Limited to shoot portions of the movie *Jonathan Livingston Seagull* in the King's Palace. Perhaps the quintessential New Age enlightenment flick to come out of the 1970s, the film was based on the best-selling book by Richard Bach, with a soundtrack by Neil Diamond. The characters in the movie were live seagulls, with dialogue overdubbed by human actors. As the gull named Jonathan discovered that he could move beyond the constraints of the physical world he knew, he found himself flying through all sorts of metaphysical landscapes no self-respecting seagull would ever visit—including Carlsbad Caverns.[4]

This shot taken during production of the 1951 movie Cave of the Outlaws *gives a glimpse of the chaotic nature of filming in the cave. Starring MacDonald Carey, about one-third of the movie was shot in the Caverns by Universal-International Films. Photographer unknown. Courtesy of Carlsbad Caverns National Park.*

Filming of The Gargoyles *in 1972 took place primarily in Left-Hand Tunnel off the Underground Lunchroom. Here K. Simpson, undoubtedly chilled in her halter-top, snuggles for warmth against Gargoyle Jim Mohlmann. Photograph by D. Collier, courtesy Carlsbad Caverns National Park.*

Since this was a low-budget film during the infancy of special effects cinematography, if a seagull was to be shown flying through a cave, that's exactly what had to be filmed. Assuming several takes were required and several stunt gulls were involved, filming the sequence probably caused a significant amount of bird-generated "impact" to the cave environment. In today's climate of "leave no trace" policies and an emphasis on science- and education-based videography at National Parks, releasing a live bird into the King's Palace would never have been permitted.

Forging A Lasting Emotional Connection

Due to the park's remoteness and the challenge of working in a poorly lit, damp environment surrounded by tourists, the park has been painted by far fewer artists than, say, Yosemite or Yellowstone. However, those artists who persevered in their pursuit of a truly memorable landscape experience in the underground wilderness of Carlsbad were richly rewarded for their efforts. In her book *Contested Terrain: Myth and Meanings in Southwest Art*, essayist and art historian Sharyn R. Udall examines the relationship between artists and landscape:

> One of our great treasures, an abundance of wilderness, has for two centuries encouraged American painters to range widely in pursuit of its spectacles

and its secrets. For some landscape painters a straightforward search for new visual material, for stunning vistas, was sufficient to lure them into the wilderness. But for others, the search had an inward component as well: they wanted to connect spiritually and emotionally with the land.[5]

One of the most striking paintings in the park's collection from this era is a large canvas painted by David Klein entitled "Cavern Interior." Created in 1968, its 48"h x 60"w size harkens back to the large paintings made by Will Shuster in the 1920s. Painted in acrylics, which only became widely available to artists in the early 1960s, the painting is an extremely successful example of a large landscape painted in this relatively new medium.

The park's records about this work of art are sparse; a notation exists that says "the artist, David Klein, visited Carlsbad in 1968 under the NPS 'Artists in the Parks' program. Donated to the NPS Archives from David Klein thru the Society of Illustrators on December 21, 1970." Unfortunately, no additional information appears to exist about Klein or his work at the Caverns.

Like Will Shuster before him, Klein was obviously very taken with the forms and colors he found in cave formations. The painting he created captures the monumental nature of the cave, and at the same time celebrates its delica-

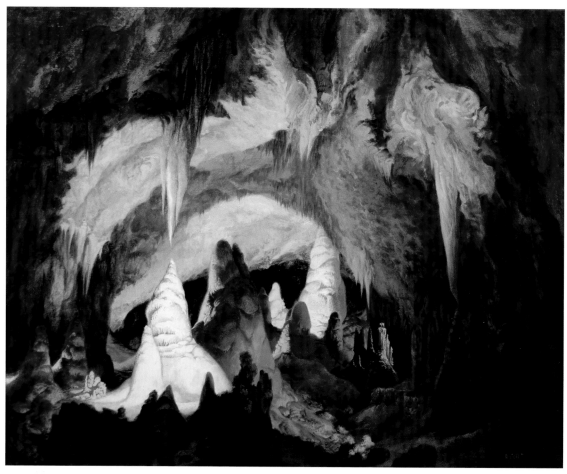

Cavern Interior *by David Klein, 1968, acrylic on canvas, 48"h x 60"w. Courtesy of Carlsbad Caverns National Park.*

cy in his portrayal of detailed shapes and flowing forms. Since it would have been impossible to work on such a large canvas in the cave, Klein must have worked from reference photographs and/or sketches. It takes many hours to paint a large, detailed landscape with acrylic paint; Klein would have had abundant time to consider the cave and its symbolic meaning for him. It is interesting to note that Klein chose to portray the cave in its "wild" state: there are no people in the painting, nor can the visitor trail be seen. While Klein depicted subtle highlights caused by the artificial lighting system, he minimized this effect and created instead a

sense of the cave as if lit from within by a pervasive glow.

Another work of art in the collection embodies a style of painting that became popular in the 1960s and is still practiced today—Photorealism. James E. "Buddy" Maddox lived in the city of Carlsbad. He then moved to Riverdale, Georgia. No other information about the artist is known. According to a business card that was attached to the rear of the painting, he specialized in "Oil painting, pen and ink drawings, and paintings from any photograph." His oil on canvas painting from 1978 entitled "Guadalupe Mountains From Carlsbad Caverns" is extremely detailed, and is an excellent example of Photorealism. Like other landscapes painted in this style, the image has a sharp, airless quality, and represents a moment frozen in time. According to NPS accession notes, the painting was "copied from a photograph by Bonnet."

The "Artist-In-Residence" Program

The National Park Services offers opportunities for visual artists, photographers, sculptors, performers, writers, composers, and craft artists to live and work in the parks. There are currently 29 parks participating in the Artist-In-Residence program. Ranging in time frame from two to six weeks, artists often stay in park housing during their residency. The program usually requires the artist to make some presentations to park visitors, and to donate at least one work of art made during their residency to the park's collection. It has been an extremely successful program for many years.[6]

Poet and visual artist John Brandi was the first Writer-In-Residence at both Carlsbad Caverns and Guadalupe Mountains National Park in Texas, a mere 30 miles away from the Caverns. Brandi's background as an internationally-known poet/artist helped him secure a grant from the National Endowment for the Arts to work at the cave. In 1978 Brandi, a native of Southern California who now lives in New Mexico, spent five months writing, drawing, and planning long prose-poems about the two parks, which were published by the Carlsbad Caverns Natural History Association in a portfolio entitled "The Guadalupes: A Closer Look." One of the poems from the portfolio is reproduced on page 103.

In his prose-poem Brandi describes in intimate detail the sights and sounds of the dawn bat-flight, when thousands of bats return to the cave after a night of feeding on insects. This event, which happens daily when the bat colony is in residence (generally April through October), is far less familiar to visitors than the evening bat flight, since it happens very early in the day, before the park officially opens.

The behavior of the bats is markedly different as well, as they abandon the leisurely counter-clockwise spiral that typifies their evening departure from the cave in favor of a high-speed dive from far above the cave, direct-

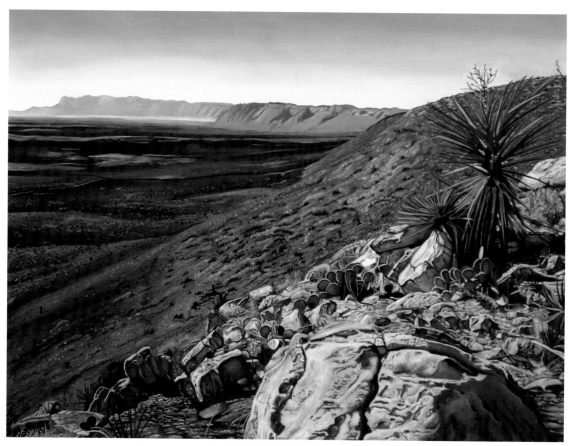

Guadalupe Mountains From Carlsbad Caverns *by James E. "Buddy" Maddox, copied from a photograph by Bonnet. 1978, oil on canvas, 34"h x 29"w. Courtesy of Carlsbad Caverns National Park.*

ly into the Cavern's entrance. Since 1957, the National Park Service has celebrated the park's bat colony every summer with a "Bat Flight Breakfast," when several hundred visitors convene at the park to be served a pancake breakfast and watch the bats return from hunting.[7]

The Making of Sound Visible Through Silence
Carlsbad Caverns National Park: A View at the Break of Dawn
by John Brandi ©1978

The still dark air at 5:45 a. m.
At one corner of the sky a hint of illumination
but not enough to matter yet. One approaches the environment
like the blind do. Odors. Drafts. Texture.
Feeling solitude, but knowing all the time that others are here, too.
Waft of guano. Damp sumac. A canyon wren laughing from somewhere
secret. Aeolian notes of wind through ocotillo.

In the heavens a single planet catches my eye
like white fire. For the first time in many years, I do not remember
anything I tried so hard to learn about that planet: name, size,
when it rises, when it sets—the sequences.
The silence here makes me forget, gives me a new shape to
meditate upon in the heavens. That fiery orb up there
is simply a note—a KEYNOTE—in the song of my quiet worship
as I sit at the edge of the caverns, waiting for morning.
Cooo-oooooo…
Is the earth yawning in this blackness?
I feel a rich and potent draft, like something from way inside.
Without seeing it, I know that in the darkness an opening is near.
It must be a massive entrance, with passages that extend forever.

Swallows, now: upward in reverse vortex!
They are barely visible, but I FEEL their flight—the swift
breeze produced by their sudden flocking, spiraling, lifting.
Their little cheeps and chatters remind me of many
unoiled winches squeaking all at once.

Strange, how we always connect the natural with man-made.
How one constantly goes back to the "civilized" world
for reference points. In the Big Room, I've heard several visitors
remark: "But is this all NATURAL?" And then draw parallels with
the work of Disneyland architects. Not so strange, perhaps.
For the natural world IS overwhelming. We are an urban society, basically,
and our culture often fails to provide any real connection between
the abstract bonds of city life and the cyclic reality of nature,
where all is interconnected; where no part stands by itself without
some vital meaning in the total pattern of Creation.

There is another sound in this silence that makes my eyes
work, too. Like something raining, but not rain.
It is audible from above, falling—and I am working hard to SEE
what it might be. Quietude is a vehicle for getting me
close—but it is not until there is enough LIGHT
that I realize what this great resonance is—a resonance like
a three-mile square bedsheet being shaken from
ground level to thousands of feet above my head.

When daybreak has fully kindled the sky and the sun is a red slit
on the horizon, you can SEE THE SOUND—the air suddenly teeming with
hairy brown acrobats that were there all the time in the dark,
just as they've been for the past 60 million years.
But you must strain a bit to glimpse the hundreds of thousands
of Mexican free-tail bats zeroing-in on the cave
after a night's feeding. They've been out since twilight, funneling
over the rim into the pink air above the Pecos River, filling their
bellies full of moths—never touching down once.

This morning the *whisssst-whup-whutter* of mammal bodies
rains upon the hole like little flicks of a delicate chisel on a
Japanese woodblock. As a mark is made, each chip that flies into the air
in turn seems to reproduce another mark—a continuous birth
of ACTION MADE INTO SOUND MADE INTO VISIBLE FRAGMENTS of a
great alphabet—about 500,000 letters worth!

The *whisssst-whup-whutter* I mention is, by itself, a
subtle vibration. But much more powerful than the actions of the
swallows, because of the NUMBERS producing it.
Imagine half a million bats tucking in their wings, letting
their bodies whistle and flap as they free-fall towards their mark,
then flipping inward to hang themselves upsidedown
250 or more to the square foot! The entire sequence is like
smoke, made of noisy flesh, reversing itself into a great limestone womb.

Add the twitter of a mocking bird against the breaking dawn,
and the silhouette—the sudden shape—of a deer's head between what you
thought to be only a stationary cluster of prickly pear,
and this, too, becomes all one more dimension. The erratic song of the
mocking bird contains ALL of the movements I have mentioned here:
the upward notes of swallow flight; the downward swoop of bats;
the horizontal prance of the doe; the rising sun; the setting planet, and
the north/south motion of clouds as they break to let sunbeams through.

The First People must have had a word for all this—
the making of Sound visible through Silence. They must have had a word,
also, for the Mexican free-tail bat—that furry little winged creature
that drops from the sky at dawn into the mouth of the earth
with a *whutter and a whirrrrrrrr…*[8]

The Natural Entrance looms ahead. As you switch back and forth on the path, you become aware that your descent is very rapid, and a great adventure has begun. *Pen and ink drawing with caption, by Robert Bausch, 1979. Courtesy of Carlsbad Caverns National Park. In his narrative, Baush records his impressions of moving ever deeper in to the cave to great effect.*

"An Other-Worldly Experience"

Artist Robert Bausch was born in 1938 in San Francisco and grew up in California. After graduating from college he was an art director for several advertising agencies in San Francisco before he launched a freelance design and illustration business in 1968. He has always had a strong interest in aviation, and has produced many paintings of aircraft, which led to his participation in the Air Force Art Program. He also made several paintings for NASA and the US Navy.

Looking Down Into Green Lake Room. A beautiful scene framed by massive stone. Here you have your first real look into the fantastic world you are entering. *Drawing with caption, by Robert Bausch, 1979. Pen and ink on illustration board, 16"h x 20"w. Courtesy of Carlsbad Caverns National Park. This is one of nine drawings donated to the park's collection during Bausch's stint as Artist-In-Residence.*

In 1979 the National Park Service commissioned him to travel to Carlsbad Caverns as part of the Artist-In-Residence Program, where he produced sketches on the spot, down in the caverns. Bausch had never been to Carlsbad before, and found being underground for hours at a time to be an unforgettable experience. This was also the first time he had been to the Southwest, and the sweeping landscapes made a lasting impression. Bausch reflects on his time in the cave:

The Papoose Room. A small, intimate room with beautiful, almost miniature formations, having somehow, a cozy feeling to it. *Pen and ink drawing by Robert Bausch, 1979, 18'h x 24"w. Courtesy of Carlsbad Caverns National Park.*

The Boneyard. Fascinating because it's so different from the usual cavern formations, with bright, warm light peeking from many openings. *Pen and ink drawing on paper by Robert Bausch, 1979, 16"h x 20"w.*

The experience of visiting Carlsbad Caverns was surely one of the most unusual ones I've ever had. What an astonishing thing the caverns are! It would have been different enough just being there. But the fact that I was actually working "down below," drawing and thinking about what I was drawing, in this very strange and awesome place, was quite a treat for the senses. Every morning after breakfast for four days I went down and sat on a campstool and started sketching. This was early in the day, and very few other people were about, if any. Down here was a truly magical world, the prehistoric depths of our planet. The lighting was very subdued, and it was extremely quiet, except for the sound of dripping water, echoing from unseen

chambers around me, as the process of the formation of the caverns continued. I will never forget this other-worldly experience.[9]

Bausch created a series of impressionistic pen-and-ink renderings on illustration board and paper of various areas in the cave, and donated a total of nine large drawings. Some of the drawings were executed using only detailed hatched ink lines, while others were enhanced with ink washes. Each drawing also has a line of hand-written text at the bottom describing the location. Documenting the process of a drawing with text as part of the finished image was very popular in the 1970s.

Caver, Poet, Artist, Ranger: Ron Kerbo

No account of the creative history of Carlsbad Caverns National Park would be complete without Ronal C. Kerbo, whose name figures prominently in the legend and lore of the National Park Service. Kerbo was a Cave and Karst Resources Specialist for the Service for thirty-one years, from 1976 until his retirement in March of 2007. At the time of his retirement, Kerbo was the National Coordinator for all the Park Service's caves resources, as well as the Interim Director of the National Cave and Karst Research Institute.[10] In many ways, he helped "write the book" about cave resource protection for the nation.

Impressive professional credentials aside, Kerbo's true legacy lies in his fierce drive to protect and conserve caves, and his support and enthusiasm for cavers and the arts. Many long-time volunteers at the park have hilarious—and sometimes hair-raising—anecdotes of run-ins with Ron Kerbo. He did not suffer fools gladly, and if he thought someone was working at cross purposes to cave conservation, that individual would quickly find him- or herself effectively "uninvited" to work at the park.

Kerbo's own caving career began in 1959 with cave diving, an activity famous for its high mortality rate. He learned to dive in the water-filled sinkholes of Roswell, a community a couple of hours' drive north of Carlsbad. Having heard a rumor that Carlsbad Caverns contained large water-filled chambers perfect for diving, he tagged along on a tour, determined to find them.

In the foreword of Nymeyer and Halliday's excellent history, *Carlsbad Caverns, The Early Years*, Kerbo describes his adventure:

Two friends and I drove over to the big cave and went on a tour. Each guide we questioned assured us that Carlsbad Cavern had no flooded chambers. Sure that I was being deceived, I soon managed to slip out of the tour group and hid behind some rocks in the Big Room. I had no doubt that I would

Mexican Freetail Bat Exit Flight *by Ronal Kerbo, 1979. The swirling column of bats rising from the cave's entrance is notoriously difficult to photograph. Kerbo took this photo long before the advent of digital photography. Photo courtesy of the artist.*

Soda Straw Stalactite *by Ronal Kerbo, 1982. Improvements in film speeds, lights, and cameras enabled photographers like Kerbo to capture the delicacy of the cave's formations as they had never been seen before. Photo courtesy of the artist.*

Beam of Sunlight in Cave Entrance *by Ronal Kerbo, 1988. This photograph, taken during the few weeks each summer that a shaft of light penetrates deep into the Natural Entrance, harkens back to a similar photograph taken by Colonel Thomas Boles in 1930 (see page 38). Photo courtesy of the artist.*

quickly find a hole leading down into both lower and wetter passages, lighted by miles of wiring and brightly glowing bulbs.

As it turned out, I could not see very well at all and had no idea where to go. I realized that if I did not soon rejoin the tour group I would be discovered and never be allowed to reenter the cave. My attempts to get back on the trail drew attention to my illegal cave exploration. I jumped down onto the trail from an eight-foot-high rock and dashed toward my friends, trying all the while to blend in with the group. It was difficult to maintain my composure as rangers searched the tour line, looking for the perpetrator of the commotion. Thankfully, no one pointed me out to the rangers, and my guilt, written plainly on my face, was not visible in the dim light."[11]

As the author and co-author of numerous books, articles, and papers on caves, bats, poetry, and skin- and scuba-diving, Kerbo has helped shape the culture of caving. In 1986 he wrote and self-published a book of poetry about the Guadalupe Mountains entitled *Bat Wings and Spider Eyes* and dedicated it "to the desert—who doesn't give a damn, one way or the other." Having lived for many years near the Guadalupe Mountains, Ron Kerbo's poetry shows a deep intuitive understanding of the clash between the ranching and mineral extraction activities of humans and the vulnerable essence of the deceptively rugged landscape.

During his years working at Carlsbad Caverns, Kerbo distinguished himself as an accomplished photographer, and took memorable color photographs of the cave and its surroundings. In 1979 he captured one of the most iconic images of the bat flight ever made, showing a dense flight of bats in front of a thunderhead still glowing with sunset light.

When asked for a biographical sketch for this book, Kerbo (true to form) modestly submitted a five-line paragraph that barely scratched the surface of his vast contributions to cave science and the arts. Many would agree that the caves of this country would be much worse off if Ron had been caught by that park ranger and expelled from Carlsbad Caverns back in 1963.

Another Photographic First: Robert Shlaer

In 1839, French artist and inventor Louis Daguerre introduced a process that would forever change man's way of representing the visual world: photography. The daguerreotype was the first photographic process; according to the Metropolitan Museum of Art, "each daguerreotype is a remarkably detailed, one-of-a-kind photographic image on a highly polished,

silver-plated sheet of copper, sensitized with iodine vapors, exposed in a large box camera, developed in mercury fumes, and stabilized (or fixed) with salt water or "hypo" (sodium thiosulphate)." [12]

Though the daguerreotype was the first photographic process, it was not until 1991 that

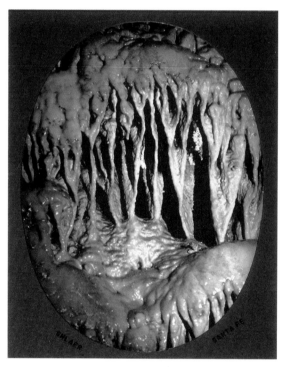

Crystal Springs Dome, daguerreotype by Robert Shlaer, 5"h x 4"w, 1991. Long exposure times and the strong light required for creating daguerreotypes made it impossible to photograph the cave's large rooms, but smaller formations could be captured in glorious detail. It is difficult to reproduce daguerreotypes; due to the metallic substrate, each daguerreotype has a slightly refractive sheen that gives the image unique depth and life. Photo courtesy of the artist.

a subterranean space was captured using this venerable photographic method. Master daguerreotype photographer Robert Shlaer chose Carlsbad Caverns as his subject and worked through the night with two Busch 4"x5" Pressman cameras and two Deardorff 5"x7" Stereoscopic cameras, plus powerful supplemental lights.

Shlaer photographed detailed areas like the Chinese Theater and the Crystal Springs Dome, using exposure times of 1-2 minutes for each photograph. After exposure, the plates were carried out of the cave to the visitor center parking lot, where they were developed in a mercury vapor bath held in a car-top carrier Shlaer rigged on his vehicle. [13]

Shlaer is the author of *Sights Once Seen: Daguerreotyping Frémont's Last Expedition Through the Rockies*, in which he retraced the steps of western explorer Charles Frémont as he searched for a central railway route in 1853. [14] Along the way, Shlaer documented the landscape with a stunning series of daguerreotypes. It's appropriate that Shlaer picked Carlsbad Caverns—the subject of the first color underground photograph as well as the largest underground photograph—as the location for his own photographic first.

Chapter Seven
The Photographic Legacy Continues

At all levels of their interest in the underground, photographers enjoy the challenge of producing pictures in limitless underground night, attempting to better their previous efforts. The cave possesses a subtle, dramatic, ruthless, beautiful, awe-inspiring environment, which, when properly cared for, changes little from generation to generation. Capturing its atmosphere and vitality has proved difficult in every age, success bringing its own rewards. With this challenge lies part of the fun, magic and satisfaction involved when man attempts "To Photograph Darkness."[1]

Author Chris Howes' excellent book *To Photograph Darkness* chronicles the evolution of underground photography, with an emphasis on European caves and mines (Chris lives in England). One connecting thread runs through the history of subterranean photography: the need for photographers to be innovative when addressing the challenges unique to working in such a hostile environment. As photographic equipment and methods evolve, the creative options available to underground photographers expand proportionately, and a new generation of cave photographers has achieved effects their predecessors could only imagine.

This chapter focuses (pun intended) on the contemporary photographers working at Carlsbad Caverns National Park—both in the main commercial cave and the "wild" caves in the park's backcountry, such as Lechuguilla Cave. For the most part, the photographs speak for themselves, and biographical information illustrates the unusual personalities represented in the caving community. Many of the images reproduced here are from prints that were gifts from the artists to the park's permanent collection. Together they form a priceless example of the best that contemporary underground photography has to offer.

Peter and Ann Bosted

Most discussions about "the world's best cave photographers" include mention of Peter and Ann Bosted. This husband and wife caving/photography team has been interested in photography since childhood. Peter honed his photographic skills while working in his parents' photo lab in Los Angeles, while Ann learned hers working as a journalist on various newspapers in South Africa.

Together they have photographed in hundreds of caves in the United States and in

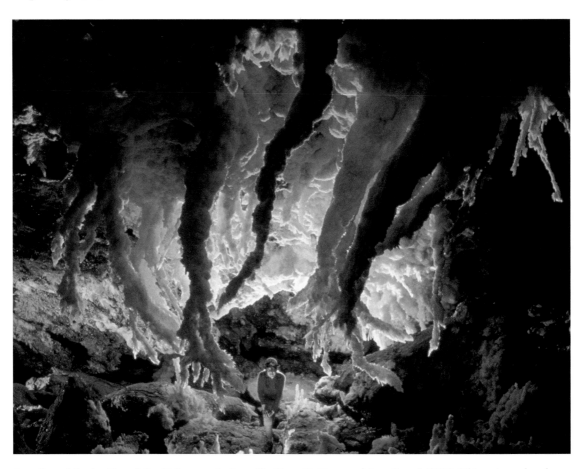

Ann Bosted in the Chandelier Ballroom, Lechuguilla Cave *By Peter and Ann Bosted, 1993. This unique chamber—several hours' hard travel from the cave entrance—is the only known example of gypsum "chandeliers" that have reached such enormous size. Some of these formations are over twenty feet long and are estimated to weigh several tons. Photo courtesy of the artists.*

about 23 countries around the world over the past thirty years. Their cave photos have won numerous awards and have been published in many books, magazines, and posters.

Ann is Chairman of The National Speleological Society's annual Print Salon, and identifying her as the model in one of Peter's photographs is made easier by her distinctive hair—waist-length, brunette double braids. When not caving, Peter does research in subatomic physics (he has a Ph.D. in physics), and writes about such topics as "Measurements of

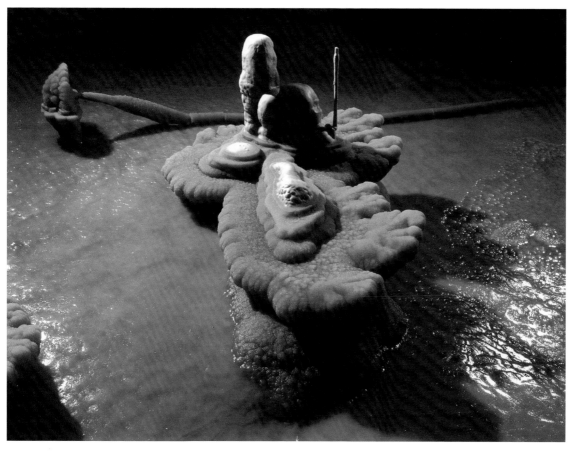

Shelfstone in The Oasis, Lechuguilla Cave by Peter Bosted and Daniel Chailloux, 2007. Some of the formations found in caves resemble abstract sculpture. In the case of this image, the lack of reference for scale enhances the abstract effect. Photo courtesy of the artists.

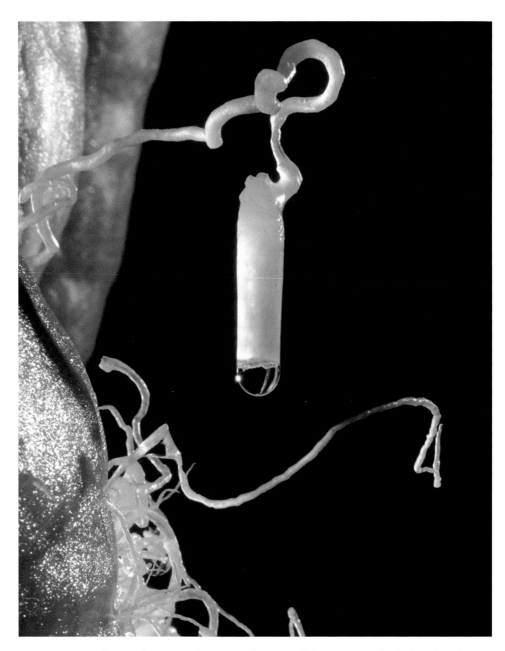

Oasis Helictite, Lechuguilla Cave *by Peter and Ann Bosted, 2007. A helictite is a small tubular calcite formation formed by water droplets and capillary action. In this way they often defy gravity. Here a soda straw grows from the tip of the helictite. The water droplet on the end of the soda straw shows that this formation is still actively growing, albeit very slowly. Photo courtesy of the artists.*

the A Dependence of Deep Inelastic Electron Scattering from Nuclei."[2]

Dave Bunnell

Few people have done more than photographer Dave Bunnell to promote public awareness of the beauty of the underground world and the need to conserve it. His award-winning images of caves have been published internationally in books, magazines, and cal-endars. A resident of California, Dave has traveled the world documenting caves of all types: sea caves, lava tubes, solution caves, and glacier caves. He has drawn on his 35-year career as a caver to create an amazing educational website about caves that he calls "The Virtual Cave." Dave is careful to put a conservation spin on all his caving communications: "Please treat all caves with respect, as these fragile formations are easily damaged. Our motto is: 'cave

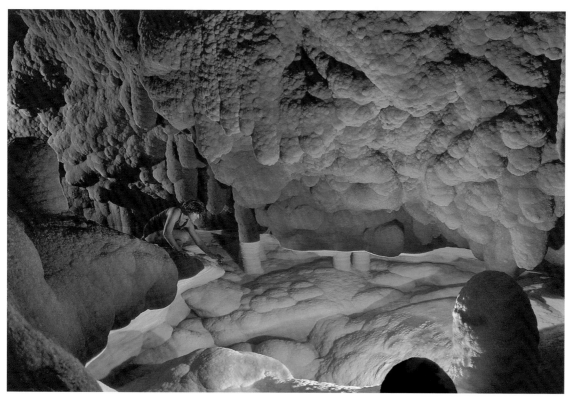

The Oasis Pool, Lechuguilla Cave *by Dave Bunnell 1988. The pool was lit by a single flashbulb on a long cord sunk into the water. Djuna Bewley is shown filling her water bottle; the larger pools in the cave contain potable water, though only a few are designated as drinking areas. Photo courtesy of the artist.*

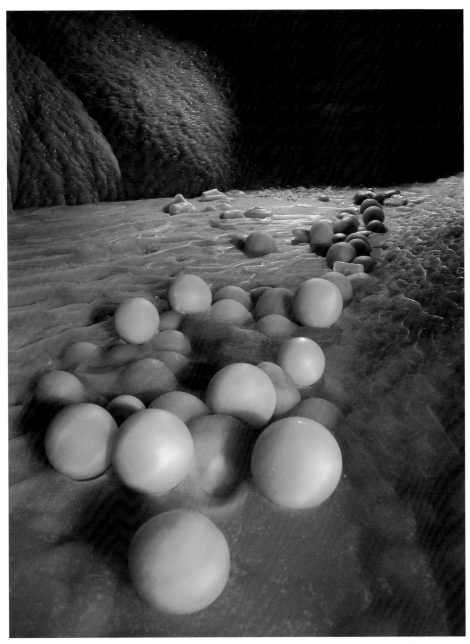

The Mother Lode, Lechuguilla Cave *by Dave Bunnell 2004. This remarkable shot of unique formations called "cave pearls" lacks a sense of scale, which amplifies its abstract qualities. Cave pearls range anywhere from pinhead to golf ball size, and often form in shallow circular basins called "nests." Perfectly cubic pearls have often been found, but are rare. Their method of formation is not completely understood.*

softly and leave no trace of your visit.'" Dave has been the editor of *The National Speleological Society's* magazine *The NSS News* for several decades.[3]

Dave has made hundreds of photographs in rugged, undeveloped caves like Lechuguilla, and writes about the advantages of shooting in "wild" caves: "without the structure of a tour, you have much more flexibility when

shooting. Indeed, the chief constraints are your equipment, the patience of those assisting you, and the need to protect the cave. The importance of the latter cannot be over-emphasized. When shooting in delicate areas, utmost care must be taken not to damage the cave. Stepping on a basin of crystals or putting a muddy boot onto clean flowstone is never justified, no matter how important it is to get the flash in

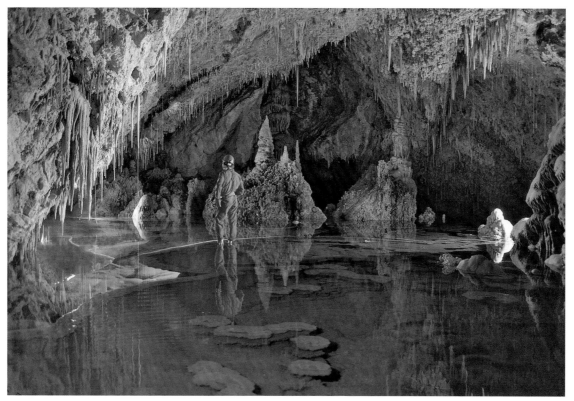

Lake Castrovalva, Lechuguilla Cave *by Dave Bunnell circa 1988. Unlike Carlsbad Caverns, Lechuguilla has several large pools containing drinkable water. Note the two different pool depths, and how Dave lit the more distant, deeper basin with a strobe. Greg Oelker is the model. Today, cavers are not allowed to touch most spelean pools due to the fragile microbes living in them.*

'just the right spot.' But there are many tricks that can be used, such as putting the flash on a monopod and holding it where you need it, or bouncing the light into the scene."

Tim Boyd

Caving enthusiasts come in all stripes, and Tim Boyd is one of the more colorful threads in the crazy-quilt of caving. A former rock musician, Tim has been a professional pho-

Roadside Speleothems *by Tim Boyd 2007. In this image, stalactites appear to have formed outside of a cave rather than inside it. Photo courtesy of the artist.*

tographer for many years, and now works as an educator in Texas. He grew up with a photo-enthusiast father and a mother who was a stickler for capturing all family events on film. His wife, Sonya, introduced Tim to caving in the 1970s and he was permanently hooked. During one of his early caving trips in New Mexico's Fort Stanton Cave, Tim was stricken with food poisoning and insists that he was visited by the ghosts of long-dead cavalry soldiers, who helped guide him out of the cave.

An important quality for any photographer is the ability to distill a visual event into its essence. Tim was able to capture an unusual aspect of the character of the Chihuahuan Desert at Carlsbad Caverns National Park in 2007, when he happened to become marooned overnight at the park during a winter storm that left the area coated with a thick layer of ice. He recalls the experience: "The fact that I was able to capture plants and minerals above ground that had such an 'underworld' look to them was pure joy to the creative side of my mind. The juxtaposition of stalagmites and stalactites intermingled with plant life was a scene not normally experienced in the realm of darkness. The fact that they were made of ice was merely a minor detail."[4]

Ocotillo with Ice, Carlsbad Caverns National Park *by Tim Boyd, 2007. The visitor trail can be seen in the background behind these ocotillo stems that have been heavily coated with ice during a January storm that closed the park for several hours. Photo courtesy of the artist.*

Chuck Burton

Chuck Burton has worked for the National Park Service for 25 years and currently serves as the Facility Manager for Carlsbad Caverns National Park. As a park staff member, his ability to have access to the cave after visitor hours has enabled him to create some especially unusual images of the cave along the much-photographed visitor trail.

An avid amateur astronomer, Chuck combined his photographic equipment and skills with his telescope and created long-exposure photographs of faint astronomical objects. His experience in working under low light conditions and taking long exposures lent itself well to working with the dimly lit subject material in caves.

When asked about the unusual range of colors that appear in his photographs of the formations in Carlsbad Caverns, Chuck explains, "the red tint is from iron oxides in the formations. Lighting in the cave also affects color tints. I shoot in the "ambient light" of the cave, with no flash or other lighting added. My goal is to show the viewer a scene as close as possible to what they saw when they were visiting down in the cave. The addition of flash or other supplemental lighting can ruin the effect. I don't use it and find that the images have more depth and color when photographed in this manner."[5]

Water Passage *by Chuck Burton, 2004. This alcove off the Lower Cave tour trail is one of the many gems captured by Burton, who has access to the cave as a staff member after hours, and is not constrained by the obstacle of working from a trail clogged with visitors during peak hours. This gives him the freedom to take as much time as needed when setting up his shots. Very often, a rushed cave photograph is a failed photograph. Photo courtesy of the artist.*

The Living Cave *by Chuck Burton, 2004. This image is a reminder that water is the foremost element of creation in a cave. Though Carlsbad Caverns is relatively dry today, the cave was much wetter, with many active formations and flowing water eons ago when it was forming and the surface environment was semi-tropical. Photo courtesy of the artist.*

The Labyrinth *by Chuck Burton, 2004. In this photograph it is easy to see how the various "temperatures" cast by the cave's commercial lighting system create colors that are not obvious to visitors in the cave. Burton uses this palette of "invisible" colors to great advantage in his prints. Photo courtesy of the artist.*

Kevin Glover

With a soft-spoken demeanor that belies his sharp wit and keen intellect, Kevin Glover is representative of many cavers—underfunded and obsessed. Though he lacks abundant financial resources, Kevin manages to spend several weeks each year avidly pursuing his addiction. The resulting collection of underground photographs Kevin has created is impressive.

He began photographing caves very shortly after beginning caving in 1989. Using an old camera with a mountable flash, Kevin and friend Tony Jones took a series of "rather dull" photos, but were at a loss for ways to improve their results. One day they decided to try side-lighting the photograph by removing the strobe from the camera, and they made a long-exposure shot by holding the shutter open for an extended period. Unknowingly, they had retraced the steps that were followed decades earlier by cave photography pioneers like Robert Nymeyer, and reached the same conclusion—that a side-directed light source placed away from the camera, coupled with long exposure

time, was the key to successful underground photographs.

Kevin's intuitive approach to photographing caves has resulted in images that possess what Kevin calls "the Wow factor." He explains what he finds satisfying about taking cave photographs: "My favorite result from sharing a cave photo is when I have a person who has been to the place where the photo is from (sometimes even a person who was on the same trip when the photo was taken), and I get the reaction of 'I hadn't seen that before' or 'I didn't know that looked like that.'"

Like many other cavers, Kevin is fascinated with geology. "My last reason for cave photography is due to the fact that I am somewhat of a rock hound at times, and I am not allowed (nor do I allow myself) to collect from caves. So instead, I have a huge collection of photos. And I can see these features any time I wish."[6]

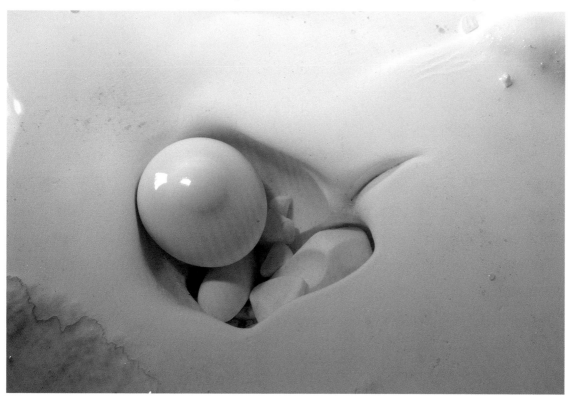

Cave Pearl, Guadalupe Room *by Kevin Glover, 1999. Like the pearls shot by Dave Bunnell, this is a highly abstract image. The "nest" pocket can be clearly seen, along with several pearls of varying shapes. It was not necessary for Kevin to use a sidelight strobe for this extreme close-up shot. Photo courtesy of the artist.*

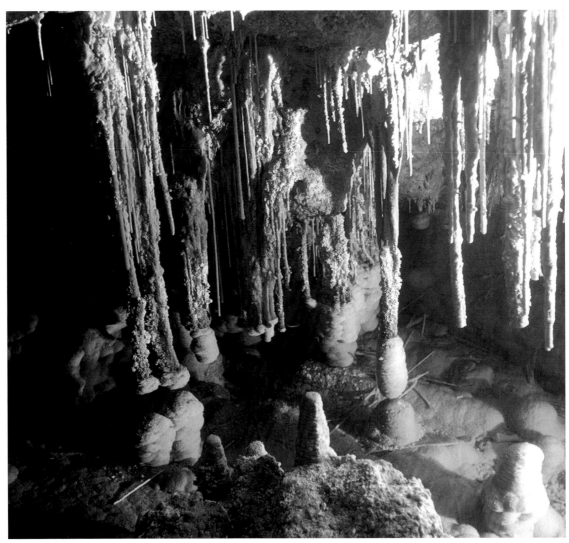

New Mexico Room Pool *by Kevin Glover, 1991. The greenish tint in the water is caused by various dissolved minerals. The New Mexico Room is a large chamber far from the visitor trail. It was once part of the guided tour, but cumulative damage caused park managers to remove the trail and close the area to visitation. Photo courtesy of the artist.*

Soda Straws in the Guadalupe Room *by Kevin Glover, 1991. This forest of soda straws hanging from the ceiling is one of the most dense examples of these formations in the cave. Each straw is approximately a foot long. Many are actively growing and sport drops of water at their tips. Photo courtesy of the artist.*

Joe Hoover and Anni Adkins

In yet another collaborative pairing, Joe Hoover and painter Anni Adkins began to work together on hand tinted photographs of the Caverns in 1994. Hand tinting was the traditional method of applying color to black and white photographs before the advent of color film. Joe first makes a black and white photograph. Anni then employs a variety of media, including photo oils and pencils and permanent inks. Each work of art is custom printed on archival paper using state-of-the-art photo printers. Joe and Anni have been in love with each other's work for more than two decades. More can be learned about their collaborative efforts in "The Photographer, The Painter, The Romance," a review by Philip Golabuk.

After beginning his career as a combat documentary cameraman filming the U.S. Air Force in action in Vietnam and the South Pacific, Joe Hoover went on to establish himself as a noted photographer and documentary

Carlsbad Mother *by Joe Hoover and Anni Adkins, 1994. This formation has, over the years, been known by such names as "The Chinaman's Hat" and "Breast of Venus." Today the formation is not distinguished by any signage giving it a name. The colors in this hand-tinted black and white photograph are not representative of the formation's actual color, which is grayish-white. Photo courtesy of the artists.*

filmmaker. He is a Cannes Film Festival "Best Documentary" Award nominee, and winner of numerous photography and film awards. Joe travels the Southwest and photographing its dramatic vistas and canyons. It's no surprise that his fascination with interesting geological forms would eventually lead him to Carlsbad Caverns.

Anni, too, seemed destined to fall under the spell of the cave. In describing her work, she writes, "I create art with emotional and spiritual meaning by painting the things that most connect me to the world. My subject matter, primarily the earth and man's mark upon it, are my way of sharing the incredible beauty of our planet and how we relate to it." Anni received her formal art training in France, and has been painting for more than 30 years.[7] Neither Joe nor Anni came to Carlsbad with a background as cavers *per se*, but they were inspired anyway.[8]

Peter Jones

Peter Jones is one of the premier underground photographers in America. He has worked professionally for many commercial cave owners, documenting their caves for promotional purposes. He cut his creative teeth in the caves of the Guadalupe Mountains, including Carlsbad Caverns and the internationally famous Lechuguilla Cave, which is also within the park's boundaries and is managed by the National Park Service for science, exploration, and research. Peter is also the U.S. distributor for Firefly Slave Units for Cave Photography, which are used for remote triggering of flash equipment.

Peter describes the beginning of his career as a cave photographer:

I started caving in 1968 in Colorado and took my first trip to the Guadalupe Mountains in the spring of 1969. My

Carlsbad Goddess *by Joe Hoover and Anni Adkins. In this hand-tinted black and white print the artist used color to emphasize a face that she perceived in the ceiling shapes near the bottom of the image. Photo courtesy of the artists.*

knowledge of photography was almost nonexistent. I felt that it was too difficult to learn the shutter speed/aperture conundrum and thus made up my own method which surely must work: If I were eight feet away from the subject, I'd set it to f/8; at sixteen feet away, I'd set it to f/16, etc. As a result, I took many memorably bad photos with the occasional successful one, just by sheer luck.

After moving to Maine in 1973, he started making annual trips to the Guads with his camera during the winter months. After much experimentation, Peter joined the long list of photographers who have taught themselves how to take pictures underground through trial and error. Ultimately, Peter's efforts paid

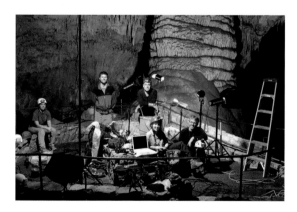

This photograph captures some of the equipment and personnel needed for a large-scale underground photographic project. Peter is on the right. Photo by Peter Jones, 2006. Courtesy of the artist.

off, and he began to make award-winning photographs of caves as his sense of aesthetics and technique evolved.

In January of 2003 he was given a grant to update the Park's Public Domain Photo Gallery, the first update in 45 years. Quickly realizing that his personal camera equipment would not be up to the task of photographing one of the largest caves in the world, Peter contacted Paul C. Buff, the manufacturer of White Lightning studio strobes and equipment. They generously loaned thousands of dollars' worth of equipment to the project team.

Peter approached the project with meticulous attention to detail and a phalanx of equipment and volunteers. His cameras included a Nikon FE 2, a Fuji Finepix 6 megapixel SLR camera with Fuji Provia F film, and a Graflex Crown Graphic 4 x 5 camera. According to Peter, "The several shots I took in my front yard suggested that this would work out fine in the cave. Sometimes it's easy to fool yourself... it later proved impossible to generate enough light in the eleven-acre Big Room to use the medium format camera at all, even with powerful spotlights."

Peter describes the special challenge of working in the Caverns:

> Carlsbad Cavern is a fairly dimly lit cave. This may be fine for the visitor experience, but it is not great for photography. The lighting systems were

installed over decades, typically using the most economical or newest lighting technologies of the day, resulting in a plethora of different lighting types: incandescent, fluorescent, mercury vapor and new experimentation with LED technology. The human eye and brain work together to "see" these various lighting types as essentially uniform "white light" falling on the area they illuminate. Cameras are far less accommodating. Photographing using the in-cave lighting can produce a wide and wild range of color variation, leading many people to swear—upon viewing their photographs—that there is colored lighting in the cave!

Hall of the White Giant, Carlsbad Caverns *by Peter Jones 2006. This is one of the ranger-guided tours available to visitors. The Park Service provides kneepads, gloves, and helmets to adventurous visitors who want to go off the paved trail for an authentic wild caving experience. Photo courtesy of the artist.*

To get around the problem of light fluctuations, Peter and his team used a series of six high-powered studio electronic strobes. The strong flash created by the strobes overpowered the relatively dim in-cave lights, giving Peter more flexibility in how each shot was lit. However, there was a slight downside to this approach:

Inevitably, the use of consistent lighting revealed the cave's true color. Although the formations in some areas of the cave are colorful (shades of red, orange and yellow are created by mineral impurities such as iron oxide), much of the cave, especially in The Big Room, is, or rather was, pure white. When Jim White first explored these areas, undoubtedly

The Natural Entrance, Carlsbad Caverns National Park *by Peter Jones 2006. This image captures the first rows of stone-lined trail switchbacks, which become progressively steeper as the trail drops deeper into the cave. Photo courtesy of the artist.*

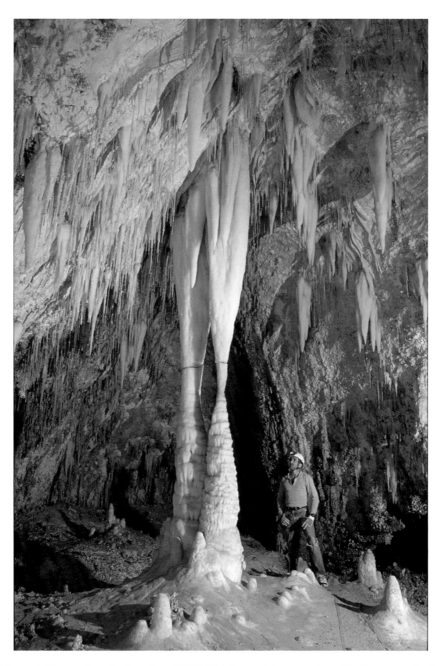

Fractured Column in Lower Cave *by Peter Jones 2006. This is one of the many beautiful features on display in the Lower Cave area of Carlsbad Caverns, another ranger-guided tour. The horizontal cracks could have been caused by a long-ago earthquake, or settling of the floor caused by shrinkage of the clays that support the formations. Photo courtesy of the artist.*

there were pristine and glistening white and wet formations everywhere. As the cave was developed for visitation, walkways installed, elevator shafts sunk, and millions upon millions of people came to see this gem of the underground, impact took its toll on the virgin beauty of the passageways. Dust, lint, and smoke from various sources lent a patina of gray to the formations. This grayness, while not generally visible due to the dim lighting in the cave, was made painfully evident by the strobe lighting.

Peter and his indispensable photographic assistant, caver Hillary Armstrong, scoped out the entire cave and planned each day's shooting, which began when the cave closed to visitors in the late afternoon. The team hauled huge loads of equipment into the cave and down the steep, switchback trail in backpacks and on a handcart affectionately christened "The Beast." They spent 2-4 hours producing each of the eighty shots requested by the Park Service. Sometimes ranger-guided tours through the scenic rooms intersected with shooting, and the crew would have to hide in the shadows until the tour went past.

Peter writes eloquently about the hidden beauty of the Caverns:

> Stretching out before us to the horizon were endless miles of darkly lit, barren desert, yet directly beneath our feet was a world of unparalleled beauty that might have been forever hidden from our eyes had it not been for the fluke of nature that created the entrance to the cave. Although our work to photograph it was satisfying, we still had a feeling of insignificance in the overall scheme of things. It was oddly calming.[9]

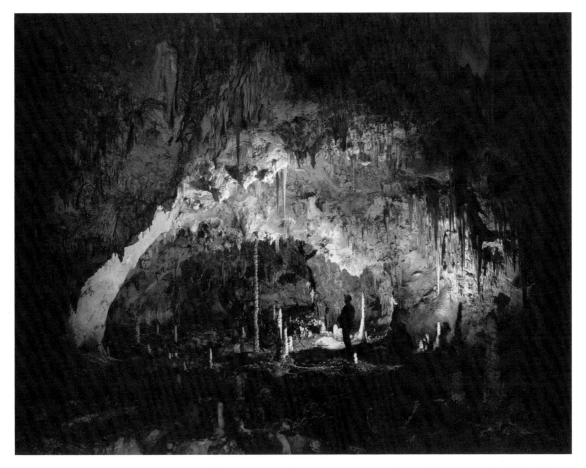

Mabel's Room *by Karst Features, 1995. Platinum print. These are unique prints because they start with a full-sized negative from which a contact print is taken, using ultraviolet light. In this case the negative was prepared digitally from a scan of the original analog negative. Photo courtesy of the artists.*

Karst Features

The collaborative team at *Karst Features* is currently the only group in Europe or North America routinely using large format cameras to document the caves of the Guadalupe Mountains. Based out of the Rayko Photo Center in San Francisco, the group has shown in juried salons, museums, and galleries on two continents.

It is unusual for a team to collaborate on cave photographs, but each individual brings special talents to the mix: Stuart Kogod is a classically trained photographer and proprietor of the Rayko Photo Center. He is the technical guru for the group. Caver and part-time Carlsbad resident Michael Queen has a Ph.D. in geology, and has worked in the Guadalupes for many years. Michael prints the color im-

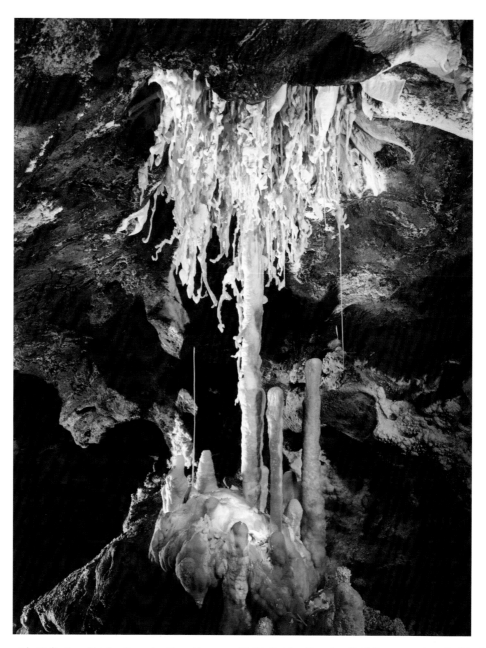

Column with Helictites, Spider Cave *by Karst Features, 1997. Spider Cave is a "wild" cave within Carlsbad Caverns National Park. Completely undeveloped, the Park Service offers ranger-guided tours to this delicate and fascinating cave. Other wild caves in the park are open to ranger-guided tours, or by permit to qualified cavers. Many other caves are completely closed except for research and science. Conventional color print. Courtesy of the artists.*

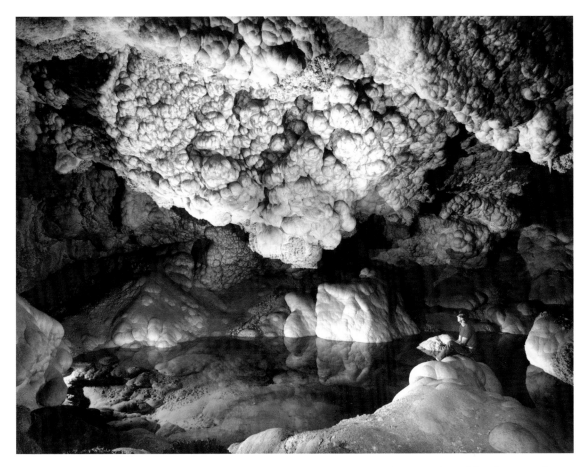

Lake of the Clouds, Carlsbad Caverns *by Karst Features, 2008. Caver Jim Burke sits on the "saddle" that protrudes into the pool. Unlike earlier pool photos, this was taken without the strobe touching the water's surface. Photo courtesy of the artists.*

ages for which *Karst Features* is known. Jack Soman is a sculptor who has been caving since 1984, and handles logistical challenges for the group as they work on location. Michael Shindler rounds out the team, sharing his passion for stereo photography and alternative techniques.

Karst Features' eclectic approach to printing makes them unique in cave photography. They print large, glossy color photo-murals, as well as incredibly subtle black and white platinum prints on paper, plus prints on other media. The artistic vision that the *Karst Features* team brings to underground photography sets them apart from other photographers.[10]

Dale Pate

Carlsbad Caverns National Park Cave Specialist Dale Pate started his photography career sometime in the early to mid 1960's when he acquired his first camera, a Kodak Instamatic. After graduating from high school, Dale began his life-long relationship with caves. His early caving years were mostly in Texas and Mexico, where he was able to bring together his love of photography and caves. In 1991, Dale became the Cave Specialist for Carlsbad Caverns. In this role he oversees researchers and cave explorers who come to the park throughout the year from all over the world. He also directs the staff of the Cave Resource Office, establishing procedures for keeping the cave environment

Backcountry Autumn by Dale Pate, 2006. A full-time ranger at the park, Dale Pate is the Cave Specialist, but makes time to roam the surface with his camera. The deep canyons in the Guadalupe Mountains contain unusual ecosystems and deciduous trees that grow along protected watercourses. Photo courtesy of the artist.

protected while providing for a satisfying visitor experience.

While Dale has done some photography in the park's caves, most of his work has focused on the seldom-visited canyons and mesas of the entire Guadalupe Mountain range in New Mexico and Texas, a landscape riddled with caves and containing some of the most rugged, unforgiving terrain imaginable. For years Dale has been drawn to this jagged limestone land where wildness has been allowed to flourish and the unexpected can be found just around the next bend of an unnamed canyon.[11]

Canyon Colors *by Dale Pate 2006. The limestone canyons of the Guadalupe Mountains make for rugged but rewarding hikes. Photo courtesy of the artist.*

John Charles Woods

Author of the essay about Ansel Adams that appears in Chapter Four, John Woods has studied with master photographers like Adams, Brett Weston, Imogene Cunningham and others. Woods' photographs have been exhibited internationally and appear in many prominent collections, including the San Francisco Museum of Art and the Ansel Adams archives. He has written two textbooks on the craft of photography: *The Zone System Craft Book* and *The View Camera Craft Book*. In 1999 Woods completed *A Restless Eye*, the definitive biography of photographer Brett Weston.[12]

A member of The National Speleological Society, John trains other cavers in vertical rope climbing and rescue techniques. He has been photographing caves since 1966, and created an interactive CD-ROM on digital cave photography in 2004, entitled *On Three! An Introduction to Digital Photography for Cavers*. A dedicated conservationist, Woods has lectured and worked throughout the United States, coordinating projects for the National Park Service and other organizations. He has been a caving technical consultant for television and motion pictures.

To Contact the Artists

The artists described in Chapters Seven and Eight continue to create beautiful artwork based on caves and other subject matter. They have generously donated examples of their cave-inspired art to the permanent collection at Carlsbad Caverns National Park, and their work can be seen in the park's visitor center gallery. To contact any of these artists, please send a message through the website www.cavernartsproject.org. Many of them also have personal websites and can be found via an online search.

Storm Cloud and Ocotillo *by John Charles Woods, 2007. This photograph was taken at Carlsbad Caverns National Park one summer evening, when thunderstorms frequently brew over the plains. Ocotillo are perennial plants native to the Sonoran and Chihuahuan deserts. Their tall spiny stems are leafless most of the year, until adequate rainfall causes small leaves to cover the stems. Photo courtesy of the artist.*

I'd Rather be Cavin'

By William Payne

People say I'm crazy 'cause of where I put my feet,
And by their standards I guess it might be true

I might be mad, but what the hell, it keeps me off the street
And there sure ain't nothin' I would rather do

You can have your cocaine
And keep your rock & roll

I'd rather be cavin'
Deep in the dark underground
I'd rather be cavin'
Water and stone all around
I'd rather be cavin'
Where I'm happy and free.

Give me darkness, deep & black & silence all around
And a friend to lend a hand when I get cold

'Cause I'm so tired of the same routine, I've got to get unwound
And I plan on pushin' leads till I get old

I don't mind them flying things
Or crawling in the mud

I'd rather be cavin'
Deep in the dark underground
I'd rather be cavin'
Water and stone all around
I'd rather be cavin'
Where I'm happy and free.

Is Earth an artist, Her canvas stone, Her brush the quiet rain?
I think I've seen her paintings in a cave
I've learned to love the hidden things that grow when left alone
That other men were kind enough to save

I've listened to the music of a cavern fantasy…

I'd rather be cavin'
Deep in the dark underground
I'd rather be cavin'
Water and stone all around
I'd rather be cavin'
Where I'm happy and free.[1]

Chapter Eight
Today's Speleoartists

During the research for this book, it became obvious that many more photographers have captured the likeness of caves than artists in any other medium. The most likely reason for this is the fact that landscape photographers often carry their equipment into difficult environments, In addition, most photographers are familiar with the use of strobes and other methods of supplemental lighting.

Artists in other media—particularly those accustomed to working in the comfort of a warm, well-lit studio—are at an extreme disadvantage when faced with the challenge of working in a cave. Even artists who routinely work *en plein aire* have the luxury of sunlight while they battle the elements and swat at mosquitoes. The ingredients found in many common art materials would be considered too toxic to risk carrying them into a delicate cave and possibly spilling turpentine or some other substance into a pristine pool. That being said, Will Shuster entered the cave in 1924 with oil paints and small panels for making studies on-site. It is not known whether he had any mishaps with his materials. Sometimes the simplest requirement—like finding a level surface to sit on—can be almost impossible.

In addition, the management of most commercial caves like Carlsbad Caverns makes it very difficult for an artist to have an extended period of uninterrupted time to concentrate on their art while working along the visitor trail. It is not unusual for a large crowd to gather around an individual engaged in almost any activity that catches the interest of visitors in the cave, and an artist working on a small drawing is no exception. In fact, there are only a few areas in the cave where the trail is even wide enough for an artist to set up a workspace without blocking the flow of visitor traffic, which is not tolerated by the rangers.

Add to these facts the requirements of physical fitness, the ability to descend and ascend ropes, and to be generally competent in a cave,

further restricts the number of individuals who would even attempt to make art underground. As a result, many artists who have wanted to portray caves have relied on photographs (taken either by themselves or others) from which they create their images in other media. In this way, photography has greatly influenced the work of most speleological artists.

Speleological art as an organized movement is relatively new to the United States, though in Europe it has been gaining popularity for several decades. Carolina Shrewsbury, a caver and educator from Great Britain who moved to the United States in 1997, has been instrumental in elevating the profile of cave-inspired fine art in this country. She established a group called "SpeleoArt" and is the Chair of The National Speleological Society's Fine Arts Salon. Thanks to Carolina's efforts, an exhibit of cave-related art in various media is a feature of the NSS' annual conventions, which are held in various cities across the country and are attended by as many as 2,500 cavers.

Carolina has written extensively about cavers and the creative process:

There is an element in a work of applied art that is emotional, never mind whether the view is realistic or one of elaborate imagination. There will be a beauty in the expression of the rock. The caver will never be bored; there is either tranquility or animation. There

is never a direct light to crash the eye. I can never view a work of speleo-art from an amateur or professional artist and not enjoy it, because in every one there will be that individual element of *I was there.*[2]

Jess Davila

New Mexico sculptor Jess Davila spent his formative years in the beautiful state of Sonora, Mexico. He grew up exploring and appreciating the unspoiled beauty of the desert and mountainous regions of his homeland. Mexico is famous for extensive limestone cave systems, and some of the world's deepest caves can be found in Central America.

Davila focuses on exploring a unique contemporary style. A completely self-taught artist, he explores his creativity in various mediums, including stone, wood, and metal. In describing his sculptures, Davila writes, "I try the extreme, and by that I mean getting the most out of the materials I use—whether by the high polish or the different textures I've created. Working in stone, I appreciate the natural colors and designs that I may encounter within, then I am guided by those colors and designs to bring out the best it can give me."[3]

Davila is also fascinated by the interaction between prehistoric humans and caves, and expresses this by including representations of small Native American-patterned bowls in his caves. "With these art pieces I want to bring

Hidden Treasures *by Jess Davila, alabaster on travertine stone base, with turquoise accents. Davila's series of cave formations are sculpted from the same kind of stone that is found in some caves, though this stone was taken from a quarry, not a cavern. He emphasizes the Southwestern origins of his inspiration by including small carvings of Native American vessels in each sculpture. The bowls are filled with small turquoise chips. From the collection of Lois and Jack Manno, on loan to Carlsbad Caverns National Park. Photograph by Pat Berrett.*

together the natural creations, the stalactites and stalagmites, as well as the history and their treasures, which might have been left there by past inhabitants."[4]

Steve Elmore

A native of the city of Carlsbad, Steve Elmore grew up wandering the rugged country of the Guadalupe Mountains, and spent many hours exploring area caves. He worked as a park ranger at the Caverns, and his aesthetic sensibility was powerfully shaped by his experiences growing up in southeastern New Mexico. He has lived in New York City, Los Angeles, and Italy, working as a travel and corporate photographer. In 1999 Steve returned to New Mexico, and now owns a shop in Santa Fe that deals in historic Pueblo Indian pottery, jewelry, and weavings. He also displays his paintings there. Describing his decision to return to New Mex-

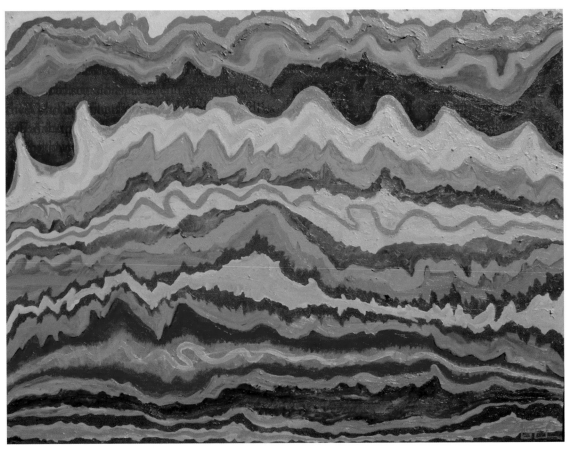

Mountains Into Rivers by Steve Elmore, 2005. Oil on canvas, 36"h x 48"w on loan from the artist to Carlsbad Caverns National Park. Elmore uses abstract forms to interpret the endless cycles of geologic change. Photo courtesy of the artist.

ico from New York, he writes: "I felt disconnected from nature, the source of all creativity, and the City was too far away from the Hopi Pueblos, another source of inspiration."[5]

He has exhibited his photographs and paintings across the country. Steve is fascinated with "themes of change and transformation."

His paintings often contain snakes and other life forms, fantastical representations of otherworldly creatures and spirit birds. Elmore sees beneath the surface of the world; it is not surprising that caves would make their way into his iconography.

The Living Cave *by Steve Elmore, 2006. Oil on canvas, 26"h x 33"w on loan from the artist to Carlsbad Caverns National Park. Elmore uses a combination of representative forms coupled with pure abstraction to capture the essence of growing, changing cave formations. Photo courtesy of the artist.*

Linda Heslop

If one artist could be said to have first popularized speleological art among American cavers, it would be Canadian artist Linda Heslop. When Lechuguilla Cave was discovered in the late 1980s, it sent shockwaves through the caving and scientific community. Here was a truly massive cave system (Lechuguilla today has well over 100 miles of surveyed cave passage) that lay within the boundaries of Carlsbad Caverns National Park, but was in no way connected to the main, commercialized cave. Hundreds of cavers flocked from all over the world to donate their time and see the wonders of "Lech." And wonders they were—huge crystal "chandeliers"

more than twenty feet long and weighing several tons each—festooning a huge chamber christened The Chandelier Ballroom was just one of the incredible features discovered deep below the New Mexico desert. Other speleothems were discovered in Lechuguilla, many of which had either never before been seen, or had never been found in such profusion.

Lech was the ultimate destination for many cave photographers, and the result of a book

This portrait by Linda Heslop shows caver Patricia Kambesis traversing a pool formation area in Lechuguilla Cave called The Oasis Pool. This highly picturesque part of the cave is represented in other photographs in this book. Based on another reference photo by Carol Vesely, this pen and ink on paper drawing was produced in 1989 and is 7"h x 8"w. Photo courtesy of the artist.

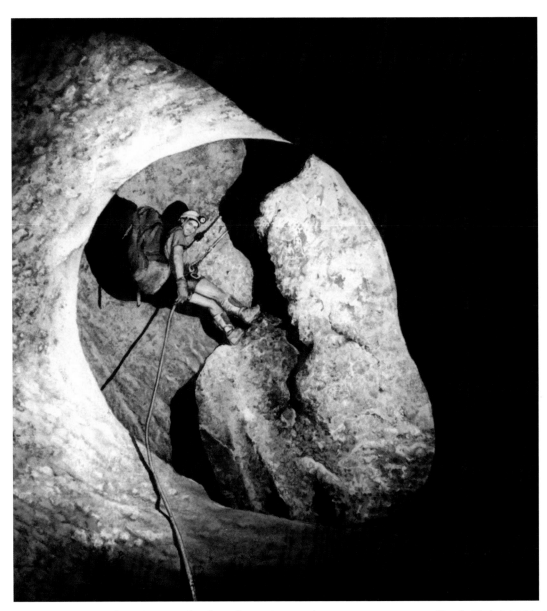

This drawing of a caver descending one of Lechuguilla Cave's many deep pits is representative of Linda Heslop's highly detailed, nearly photorealistic approach. Based on a photograph taken by caver Carol Vesely around 1998, the original is in a private collection. Watercolor and pencil on paper, 12"h x 16" w. Photo courtesy of the artist.

by Swiss photographer Urs Widmer opened up the beauty of Lechuguilla for non-cavers. *Lechuguilla, Jewel of the Underground* was first published in 1991, with a second edition in 1998. One of the most stunning speleological photography books ever published, it included black and white illustrations by Linda Heslop.[6]

In 1996 a book featuring Linda's speleological art was published. Entitled *The Art of Caving*, this book cemented Linda's reputation as North America's premier caver-artist of that decade.

Linda paints mainly in watercolors adding highlights of water pencils to add depth to her work. She has had international acclaim for twenty years for her award-winning cave art and her other paintings, which are in collections worldwide. She works from photographs taken by other cavers, and focuses on the people who explore and recreate underground. She writes: "Although the caves themselves are unique, fragile, and wonderful, my objective has been to portray the human aspect of caving. It is my hope that through my artwork I can capture for others to see the rare qualities I have encountered and admired in my fellow cavers, traits such as dedication, endurance, love of adventure, and camaraderie beyond compare, which, accompanied by a sometimes twisted sense of humor, make them such a rare breed."[7]

Elżbieta Kaleta

Not all people who are inspired by Carlsbad Caverns National Park are cavers. Polish-born artist Elżbieta Kaleta came to the United States in 1981 for postdoctoral research after earning a Ph.D. in biology. She is a practitioner of the ancient Polish folk art tradition of paper cutouts the sheet with scissors to leave a pattern. Often one picture is made up of multiple layers of cutout (called *Wycinanki* in Polish), by which an image is crafted from paper by cutting away parts of sheets.

Carlsbad Caverns II by Elżbieta Kaleta, 1995, paper cutout 18"h x 18"w. This circular design is reminiscent of ancient Mimbres Indian pottery. Bats were a popular element of Mimbres pottery designs. Here Kaleta uses designs from a number of Mimbres patterns to create a fanciful bat flight.

Carlsbad Caverns I *by Elżbieta Kaleta, 1992, paper cutout 26"h x 23"w. Kaleta's cutouts have become popular notecards sold in the Caverns bookstore. Her interpretation of the cave formations is combined with Mimbres-inspired bats and other figures, plus a border of geometric shapes reminiscent of a folk art quilt pattern. Courtesy of the artist.*

Traditional Polish designs include flowers, birds, tree-of-life, and geometric patterns. She expanded her visual vocabulary over the years as a response to her growing love of the Southwest. A visit to Carlsbad Caverns and its intricate formations inspired Elżbieta to interpret the cave in paper. In addition, she added bats and other creatures inspired by the ancient pottery designs of the Mimbres Indian tribe to further enhance the whimsical aspect of her cave cutouts. These high-contrast designs in stark black and white show great accuracy in how the complex speleothems are portrayed, no doubt a reflection of her time spent as a scientific illustrator. This combination of fantasy and reality creates wonderful tension in her work.

Elżbieta's paper artistry has been exhibited internationally, and she has received many awards for her work. Paper is not her only medium: she has also created murals, and works in ceramic and photography. She also teaches her craft in schools and museums.[8]

Tim Kohtz

Anyone who wants a tattoo of a bat, a caver, a cave passage, a gigantic centipede, or any number of other unusual images should first talk to caver/tattoo artist Tim Kohtz. A gifted draftsman, Tim can transform almost any fantasy into reality—either on paper or on skin. Tim created a series of large-format, photorealistic drawings on paper based on well-known

The Veiled Statue *by Tim Kohtz, 2007 graphite on paper, 14"h x 8"w. Photo courtesy of Carlsbad Caverns National Park. Tim's work continues the tradition of photorealism at the Caverns.*

formations along the visitor trail in the cave's Big Room, such as the Temple of the Sun and the Rock of Ages.

Born in Chicago in 1962, Tim has drawn pictures ever since he can remember. Much of his youth was spent in Indiana, the state where he first ventured underground and became active with caving. A teacher in high school, Raymond Melevage, first encouraged Tim to take his drawing skills seriously. After receiving a scholarship in art to Texas Tech University, Tim moved to Lubbock in 1981. He works full time there as a tattoo artist, and spends much of his spare time drawing, painting and caving in the Carlsbad area.

Tim volunteers at Carlsbad Caverns National Park with the Cave Research Foundation, and is both a surveyor and sketcher, leading teams into the cave to continue mapping its passages. Amazing as it seems, Carlsbad Caverns has been mapped in its entirety several times since it was discovered at the turn of the 20th century. Advancements in survey equipment, higher survey standards, and the need to correct old errors has necessitated re-mapping the Cavern. Each time, additional passages are discovered, though no significant new areas have been added to the cave's profile since the early 1990s.

Temple of the Sun *by Tim Kohtz, 2007 graphite on paper, 36"h x 28"w. On loan from the artist to Carlsbad Caverns National Park.*

Andy Komensky

Irascible, irreverent, with an almost fanatical dedication to protecting caves, retired NPS ranger Andy Komensky is truly one of a kind. A New Mexico caver for over 40 years, Andy now lives in Saint Louis, where he captures his caving memories in watercolor and mixed media (coffee is a favorite tinting medium for working on paper). He has been honored by The National Speleological Society as a Fellow, and spent many years prowling the visitor trails

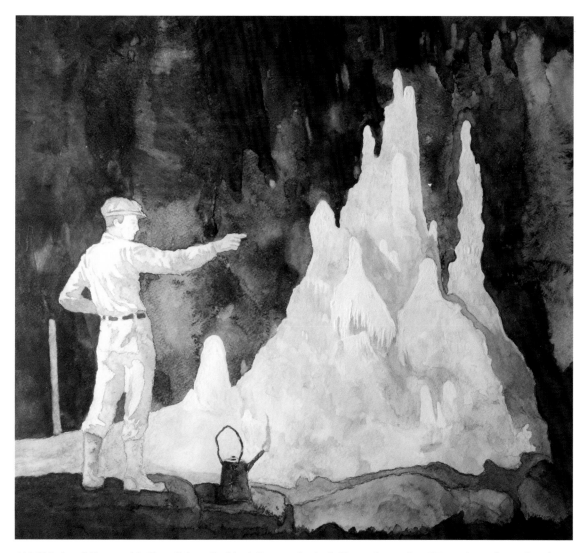

1924 National Geographic Expedition, Carlsbad Caverns *by Andy Komensky, no date. Watercolor and mixed media on paper, 17 ½"h x 19"w courtesy of the National Cave Museum, Diamond Caverns, Park City, KY. Andy creates an almost sepia-tone effect using watercolor and coffee washes in this painting, reinforcing the historical subject matter. Photo courtesy of the artist.*

of Carlsbad Caverns National Park, watching out for cave visitor vandals and overly enthusiastic would-be explorers. He is fascinated by the early expeditions by groups like the National Geographic Society, and many of his Carlsbad paintings are reminiscent of early explorers like Jim White, showing figures wearing period garb and carrying old-style lanterns. Some of

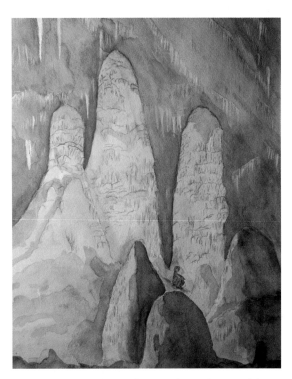

Jim White at the Hall of Giants *by Andy Komensky, no date. Mixed media on paper, 13½"h x 10½"w. This painting is based on a famous early photograph of cavern explorer Jim White crouching at the base of two enormous stalagmites in the cave's Big Room. Photo courtesy of the artist.*

Lois Manno

A caver since 1979, I began working as a volunteer at the park in the mid-1990s. Most of my time was spent helping to map the cave, cleaning damaged formations, and other projects. I have always enjoyed depicting geologic forms and landscapes, but it wasn't until I began caving at Carlsbad Caverns that speleolog-

Soda Straws II *by Lois Manno, 1998. Acrylic on paper, 19"h x 14"w. Here the line between abstraction and realism begins to blur. Based on a photograph, I enhanced the colors but the forms are true to life. From the collection of Jennie McDonough. Photo courtesy of the artist.*

his favorite reference materials include historic photographs of those early years. Andy's work is very popular in the caving community, and he sells almost everything he paints. Andy is completely self-taught, and brings a fresh, primitive eye to the subject of cave art.[9]

Nightfall Over Carlsbad *by Lois Manno, 2006. Scratchboard, 12"h x 9"w. From the collection of Dale Pate and Paula Bauer. In this drawing I show the interface between above and below, in a stylized crosssection. The bat flight is shown against a dusk sky. Photo courtesy of the artist.*

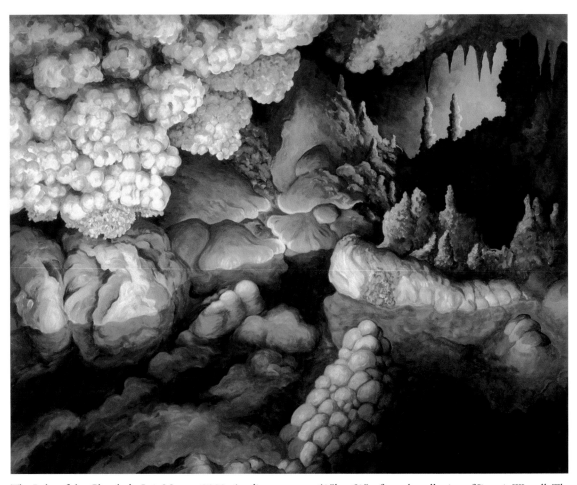

The Lake of the Clouds *by Lois Manno, 2003. Acrylic on canvas, 48"h x 60"w from the collection of Jimmie Worrell. The Lake of the Clouds is the deepest point in Carlsbad Caverns, and is far from the visitor trail. Accessing the chamber requires a descent of several hundred feet on ropes. Photo courtesy of the artist.*

ical art became a focus for my work. I've made dozens of paintings, drawings, pastels, collages, and scratchboard pieces inspired by caves. I participate in The National Speleological Society's annual Fine Arts Salon.

Like most other speleological artists, most of my work has been based on photographs generously shared with me by fellow cavers.

Though I have made art in other caves, it was not until early in 2008, in fact, that I joined fellow caver-artist Tim Kohtz in an afternoon of sketching in the Big Room with pastels. It was Tim's first experience drawing inside a cave, and we both found it to be exhilarating, working in such an enormous space with so many options. It was a bit challenging, as we

had to stop work frequently to talk with visitors about what we were doing. At one point, we were surrounded by more than a dozen curious onlookers asking questions. Part of our training working at the Caverns as volunteers is to always "interpret" for the visitors whatever we're doing along the trail. It came in handy during that day of sketching!

Unlike artist Linda Heslop, my focus in depicting caves is not the human element so much as a fascination with the amazing forms found underground. I enjoy playing with the interface between realism and abstraction; many times an image I have painted that looks completely abstract will, in fact be a realistic representation of exactly what exists in the cave. I find it interesting that structures commonly found on the surface, such as snow and ice, have almost identical corollaries in mineral form underground. I have seen gypsum (calcium sulfate) deposits that completely mimic snowbanks and icecicles. Another fascinating visual aspect of caves is the almost complete lack of perfectly straight lines and square corners. After spending several days camping and working underground in Lechuguilla Cave, I was spellbound for several hours by the crisp intersections between walls and ceilings inside the building where I was staying. Eventually the effect wore off as my senses readjusted to a world with right angles.

Wren Prather-Stroud

Carlsbad resident and classically trained sculptor Wren Prather-Stroud has studied art and architecture all over the world, including Egypt, Israel, and Europe. She has worked in bronze since 1978, and her work is in collections internationally. She has several sculptures

Jim White *by Wren Prather-Stroud, 2008. Mixed media on paper, 18"h x 12"w. This sketch was a study for a sculpture to commemorate Jim White's discovery and exploration of Carlsbad Caverns. It has not yet been cast into bronze. Courtesy of the artist.*

on display in the city of Carlsbad. Wren describes her art:

"The human figure is endlessly interesting to me and is the central focus of my work. I particularly enjoy combining the figure with other elements in order to express specific feelings or stories.

I have an extensive knowledge of anatomy, which I use in a very non-mechanical way to create figures that have a natural grace. Their pose never appears forced or strained. My strengths are a sensitive aesthetic judgment, an ability to find and portray the beauty of being human, and a discerning feel for composition. For me, a beautifully done figure is not enough…the art quality of the overall piece is a priority."[10]

When the City of Carlsbad decided to request submissions for a sculpture commemorating Jim White's discovery and exploration of Carlsbad Caverns, Wren submitted a proposal. Though her concept was not ultimately selected, the drawing she created is very powerful, depicting Jim at the moment just before he first sets foot onto the cavern floor after descending a rickety ladder into unknown depths. A shy and retiring character by nature, it no doubt would have amazed and embarrassed Jim to know how many times his likeness has been used to capture the essential wonder of exploration and adventure.

The Future of Art at Carlsbad Caverns National Park

This sampling of artists is by no means representative of every hand that has ever been inspired to draw, paint, or sculpt Carlsbad Caverns. Nor will the history of art at this national park end with this book. Every day, thousands of visitors throng the trails, marveling at the immense beauty of this natural work of art. Every year new creative energy flows from the cave into the minds and hearts of people who travel from all over the world to view its wonders.

Carlsbad Caverns Superintendent John Benjamin has shown a strong commitment toward giving the arts a presence at Carlsbad Caverns. In October of 2008, the National Park Service celebrated the completion of a multi-year renovation of the park's visitor center. The new center now includes a 500 square-foot permanent exhibit area that will be used to display the park's art collection, including the original Ansel Adams photographs that were made in 1941. In addition, there are plans to revitalize the park's Artist-in-Residence program, which brings artists into a national park for several weeks to work, give presentations, and generally help engage the public and educate them about the importance of art at national parks.

At a national park like Carlsbad Caverns, where staggering beauty drove early explorers ever deeper, it is only natural that exploration in all creative media—literature, music, photography, painting—should be celebrated here.

Afterword

One afternoon I was driving down Cerrillos Road in Santa Fe, past Stephen's Consignment Gallery, a venerable establishment where many of the art and antique treasures of Santa Fe eventually come to rest until they are purchased by new owners. On a whim, I pulled in to see what work by Will Shuster or his contemporaries might have ended up on the walls there.

To my absolute amazement, not only were there several small Shuster paintings, but one piece dated 1961 showed a highly abstracted "bat flight." Known almost exclusively as a representational painter, Shuster rarely ventured into the world of abstraction, which makes this piece especially unique.

When I inquired further, I was told by staff member and walking art history book Glen Smith that this painting was one of several Shuster made as gifts for his sister Carol late in his life (he died in 1969). Obviously, Shuster started with loosely defined strokes of color, then went in after the paint was dry with black ink and delineated the shapes of several bats, with small specks in the upper right-hand corner representing the column of distant bats streaming away from their roost—Carlsbad Caverns, one can only assume.

I found this painting to be particularly poignant, considering what I'd learned about Will Shuster during my research for this book, and what I knew from personal experience about caves: once caving gets into your blood, you're never the same. I pictured Shuster sitting in a comfortable studio with friends (he would

Bat Flight *by Will Shuster, 1961. 4½"h x 3"w, oil on paper with ink. The signature at the bottom is in pencil. From the collection of Carol and Tyler Dingee, courtesy of Stephen's Consignment Gallery, Santa Fe.*

often gather with other artist to socialize and make small paintings like this one), gazing at this small abstract study as his mind wandered back almost 40 years to his days as a caver-artist at Carlsbad Caverns.

This small painting is a testament to the power of beauty as embodied by America's National Parks—these places that have the capacity to expose people to life-altering experiences.

Shuster was changed forever by his trips into Carlsbad Caverns, as I have been, and as many of my friends have. I'm confident that many of the millions of people who have visited Carlsbad Caverns National Park over the decades have come away with a renewed appreciation for the wonders of this planet, and the need to preserve those wonders for future generations.

The main exhibit space in the Carlsbad Caverns visitor center. The large painting on the right is "The Dome Room" by Will Shuster.

Endnotes

Chapter One

[1] Ballew Neff, Emily. *The Modern West: American Landscapes 1890-1950*. New Haven: Yale University Press in association with the Museum of Fine Arts Houston, 2006, 15.

[2] Runte, Alfred. *National Parks: The American Experience*. Lincoln: University of Nebraska Press, 1997, 2.

[3] Rothman, Hal K. *Promise Beheld and the Limits of Place: A Historic Resource of Carlsbad Caverns and Guadalupe Mountains National Parks and the Surrounding Areas*. Washington, D.C.: Department of the Interior, National Park Service, 1998, 140.

[4] Long, Abijah and Joe N. Long. *The Big Cave*. Long Beach: Cushman Publications, 1956, 16-28.

[5] White, James Larkin. *Jim White's Own Story: The Discovery and History of Carlsbad Caverns*. Carlsbad: Carlsbad Caverns Guadalupe Mountains Association, 1998, 14.

[6] Carlsbad Caverns National Park Cave Resource Office: *2007 Historic Signature Survey*.

[7] Rothman, *Promise Beheld and the Limits of Place,* 151-152.

[8] Rothman, *Promise Beheld and the Limits of Place,* 146.

[9] Loomis, Sylvia. "Oral History Interview With Will Shuster, Santa Fe New Mexico." Washington, D.C.: The Smithsonian Archives of American Art, 1964. <http:www.aaa.si.edu/collections/oralhistories/transcripts/shuster64.htm>

[10] Dispenza, Joseph and Louise Turner. *Will Shuster, A Santa Fe Legend*. Santa Fe: Museum of New Mexico Press, 1989, 16.

[11] Robertson, Edna C. *Los Cinco Pintores*. Santa Fe: Museum of New Mexico, 1975, 9.

[12] Loomis, Sylvia. "Oral History Interview With Will Shuster," 3.

[13] Loomis, Sylvia. "Oral History Interview With Will Shuster," 4

[14] Gerald Peters Gallery. *The New Mexico Painters*. Santa Fe: Gerald Peters Gallery, 1999, 71.

[15] Gerald Peters Gallery. *John Sloan and Will Shuster, A Santa Fe Friendship*. Santa Fe: Gerald Peters Gallery, 1993, 37.

[16] Robertson, Edna and Sarah Nestor. *Artists of the Canyons and Caminos: Santa Fe, The Early Years*. Salt Lake City: Peregrine Smith, Inc., 1976, 107.

[17] Robertson and Nestor, *Artists of the Canyons and Caminos: Santa Fe, The Early Years*, 107.

[18] Grand Canyon Trilogy brochure, University of New Mexico Art Museum.

[19] Chip Ware, Curator of the Jonson Gallery, Albuquerque, New Mexico. Personal communication, 2008.

[20] Garman, Ed. *The Art of Raymond Jonson, Painter*. Albuquerque: University of New Mexico Press, 1976, 100.

[21] University of New Mexico. "The Jonson Gallery History." <http://www.unm.edu/~jonsong/history.htm.>

[22] University of New Mexico. Raymond Jonson quote from interview, Grand Canyon Trilogy brochure.

[23] Loomis, Sylvia. "Oral History Interview With Will Shuster," 17.

Chapter Two

[1] Bunnell, Dave. "Cave Photography: Getting Good Pictures in Nature's Darkroom." Good Earth Graphics, 1996. <http://www.goodearthgraphics.com/showcave/photo.html>

[2] Howes, Chris. *To Photograph Darkness: The History of Underground and Flash Photography*. Carbondale: Southern Illinois University Press, 1989, 58.

[3] Nymeyer, Robert and William R. Halliday, M.D. *Carlsbad Cavern, the Early Years: A Photographic History of the Cave and Its People*. New Mexico: Carlsbad Caverns Guadalupe Mountains Association, 1991, 55.

[4] Nymeyer and Halliday, *Carlsbad Cavern, the Early Years,* 58.

[5] Holley, Robert F. "Report on Carlsbad Cave." United States Department of the Interior, Bureau of Land Management. 1923, 9.

[6] Hoff, Bob. "The Importance of Ray V. Davis in Early Caverns History." *Canyons & Caves*, Summer 2004, 5.

[7] Davis, Ray V. "Lens of the Labyrinth." *New Mexico Magazine*. Sept.-Oct. 1970, 25.

[8] Davis, "Lens of the Labyrinth," 25.

[9] Nymeyer, Robert. *Carlsbad, Caves, and a Camera*. Saint Louis: Cave Books, 1993, 34.

[10] Rothman, Hal K. *Promise Beheld and the Limits of Place,* 148.

[11] Rothman, Hal K. *Promise Beheld and the Limits of Place,* 148.

[12] Rothman, Hal K. *Promise Beheld and the Limits of Place,* 149.

[13] Holley, Robert F. "Report on Carlsbad Cave," 9.

[14] Lee, Willis T. "A Visit to Carlsbad Cavern: Recent Explorations of a Limestone Cave in the Guadalupe Mountains of New Mexico Reveal a Natural Wonder of the First Magnitude." *The National Geographic Magazine*, January 1924, 9.

[15] Nymeyer and Halliday, *Carlsbad Cavern, the Early Years,* 92-94.

[16] Livingston, Carl. "Other Men's Bones." *New Mexico Magazine*, January 1934, 19-20.

[17] Nymeyer and Halliday, *Carlsbad Cavern, the Early Years,* 94-95.

[18] "Carlsbad Caverns Reveals Marvels." *The Hartford Courant*, Apr. 22, 1925; ProQuest Historical Newspapers, *Hartford Courant* (1764-1984), 5.

[19] "Color Theory: Additive Color Synthesis." By J. Scruggs <http://home.bway.net/jscruggs/auto.html#the>

[20] "National Geographic Milestones: Photography." *National Geographic* 1996-2007. <http://photography.nationalgeographic.com/photography/photos/national-geographic-milestones.html>

[21] Nymeyer and Halliday, *Carlsbad Cavern, the Early Years,* 100.

[22] Nymeyer, *Carlsbad, Caves and a Camera*, 3.

[23] Nymeyer *Carlsbad, Caves and a Camera,* 3.

[24] Greene, Edward J. *Carlsbad Caverns: The Story Behind The Scenery*. Las Vegas: KC Publications, Inc., 2006, 8.

[25] Nymeyer, *Carlsbad, Caves and a Camera,* 6.

[26] Nymeyer, *Carlsbad, Caves and a Camera,* 36.

[27] Nymeyer, *Carlsbad, Caves and a Camera* 44.

Chapter Three

[1] Rothman, *Promise Beheld and the Limits of Place*, 170.

[2] Nymeyer and Halliday, *Carlsbad Cavern, The Early Years*, 115.

[3] Boles, Thomas, "Superintendent's Monthly Report," August 1937.

[4] Allan J. McIntyre Fine Art artist online biographical information <www.allanmcintyre.com/erixon.htm>

[5] Gordon Smith, Director, National Cave Museum, Diamond Caverns, Park City, KY. Personal communication, 2008.

[6] Hoefer, Jacqueline. *A More Abundant Life: New Deal Artists and Public Art in New Mexico*. Santa Fe: Sunstone Press, 2003, 15-43.

[7] Hoefer, *A More Abundant Life*, 44.

[8] Nymeyer and Halliday, *Carlsbad Cavern, The Early Years*, 44-45.

[9] Lee, Willis T. "A Visit to Carlsbad Cavern." *The National Geographic Magazine*, January 1924, 32-35.

[10] Grauer, Michael R. "Women Artists of Santa Fe." Traditional Fine Arts Organization, Inc., 2003-2004.

[11] "Women Artists of the American West" by Phil Kovinick and Marian Yoshiki-Kovinick. Courtesy Robert Stanfield of Owings-Dewey Gallery, Santa Fe, NM.

[12] Flynn, Kathryn. *Treasures on New Mexico Trails: Discover New Deal Art and Architecture*. Santa Fe: Sunstone Press, 1995, 126-127.

[13] Boles, Thomas. "Superintendent's Monthly Report" February, 1934, 5.

[14] Loomis, Sylvia. "Oral History Interview With Will Shuster," 5-8.

[15] Dispenza, and Turner. *Will Shuster, A Santa Fe Legend,* 57.

[16] National Park Service Accession Lists, Carlsbad Caverns National Park, 2008.

[17] DeNoon, Christopher. *Posters of the WPA.* Seattle: The University of Washington Press, 1987, 32.

[18] Bamberger, Alan. "The Government Wants Its WPA Art Back." 2000, 1-3. <http://www.artbusiness.com/wpa.html>

[19] Leen, Doug. "Ranger Doug's Enterprises" <http://www.rangerdoug.com>

[20] Leen, Doug. "Ranger Doug's Enterprises" <http://www.rangerdoug.com>

Chapter Four

[1] Adams, Ansel. *Our National Parks.* Edited by Andrea G. Stillman and William A. Turnage. Boston: Little, Brown and Company, 1992.

[2] Hoff, Bob, NPS Historian (retired). Personal communication, October, 2007.

[3] Boles Thomas, "Superintendent's Monthly Report," December 1936.

[4] Gerald Peters Gallery. "Ansel Adams: Monumental Classical Photographs" Exhibit overview, Santa Fe, New Mexico. Exhibit co-sponsored by the Andrew Smith Gallery, March 14-April 20, 2003.

[5] Kerbo, Ron, NPS National Cave Specialist (retired). Personal communication, August, 2006.

[6] Adams, Dr. Michael. Personal communication, April, 2008.

[7] Adams, Dr. Michael. Personal communication, April, 2008.

[8] Alinder, Mary Street and Andrea Stillman. *Ansel Adams: Letters and Images 1916-1984,* Boston: Little Brown and Co., 1988, 87-88.

[9] Kleinfelder, Dr. Karen. Personal communication with John Charles Woods. Long Beach, CA, 1997.

[10] Newhall, Nancy, *The Eloquent Light.* San Francisco: Sierra Club Press. 1963, 17.

[11] Alinder and Stillman. *Ansel Adams: Letters and Images 1916-1984,* 87-88.

[12] Alinder and Stillman. *Ansel Adams: Letters and Images 1916-1984,* 87-88.

[13] Attributed to Adams by numerous sources.

[14] Woods, John Charles. Personal interviews/talks with Ansel Adams 1973-1984.

Chapter Five

[1] Hoff, Bob. "Retired Park Historian's CAVE/NPS History" entry from July 18, 2006. <http://www.carlsbadcavernshistory.blogspot.com>

[2] Violett, Lecie McDonald, "Underworld at Carlsbad," *The Desert Magazine,* August 1939, 16.

[3] Hoff, Bob. "Park Historical Anniversary" memo to Carlsbad Caverns staff, December 5, 2004.

[4] Rothman, *Promise Beheld and the Limits of Place,* 196.

[5] Johns, Joshua Scott. "All Aboard: The Role of the Railroads in Protecting, Promoting, and Selling Yellowstone and Yosemite National Parks" Master's Thesis from the University of Virginia, 1996.

[6] "Carlsbad Caverns National Park" promotional booklet, December 1940, 18.

[7] "Carlsbad Caverns National Park" promotional booklet, 11.

[8] Boles, Thomas, "Superintendent's Report," February 1935, 11.

[9] Riskin, Marci. *The Train Stops Here: New Mexico's Railway Legacy.* Albuquerque: University of New Mexico Press, 2005, 47.

[10] Johns, "All Aboard: The Role of the Railroads in Protecting, Promoting, and Selling Yellowstone and Yosemite National Parks."

[11] Jones, Eleanor, and Florian Ritzmann. "Coca-Cola at Home" online article, <http://xroads.virginia.edu/~class/coke/coke1.html>

[12] Coca-Cola Company ad, "The Pause that Refreshes," *The Saturday Evening Post*, July 11 1931, 1.

[13] Howes, *To Photograph Darkness*, 238.

[14] Sutherland, Mason, "Carlsbad Caverns in Color," *The National Geographic Magazine*, October 1953, 440.

[15] Howes, *To Photograph Darkness,* 240.

[16] Sutherland, "Carlsbad Caverns in Color," 452.

[17] Howes, Chris (same information) page 241.

[18] Pillen, Corey, "See America: WPA Posters and the Mapping of a New Deal Democracy," *The Journal of American Culture*, March 2008, 62.

[19] Wilkinson, Todd, "The Cultural Challenge: Parks and Cultural Diversity," *National Parks Magazine*, January 2000.

[20] Merritt, Helen, and Nanako Yamada. *Guide to Modern Japanese Woodblock Prints: 1900-1975*, Honolulu: University of Hawaii Press.

[21] Halliday, William R., M.D. Personal communication, July, 2008.

[22] Marshall, Terry, "Carlsbad Caverns National Park's Five Guided Off-Trail Tours," online article, SouthernNewMexico.com, January 2003. <http://www.southernnewmexico.com/articles/southeast/eddy/carlsbad/carlsbadcavernsnationalpa-2.html>

[23] Lindsley, Pete. Personal communication, October, 2008.

Chapter Six

[1] Rothman, *Promise Beheld and the Limits of Place*, 16.

[2] Hoff, Bob, Carlsbad Caverns National Park Historian (retired), "Historical List of Commercial Filming at Carlsbad Caverns, 1924-1993." <http://carlsbadcavernshistory.blogspot.com/2007_11_01_archive.html>

[3] DeWitt, Dave, *New Mexico: Discover the Land of Enchantment*. Houston: Gulf Publishing, 1994.

[4] Wikipedia, description of *Jonathan Livingston Seagull* <http://en.wikipedia.org/wiki/Jonathan_Livingston_Seagull>

[5] Udall, Sharyn R. *Contested Terrain: Myth and Meanings in Southwest Art*. Albuquerque: University of

New Mexico Press, 1996, 9.

[6] For more information about the Artist-In-Residence Program and to view a list of participating parks, visit the National Park Service's Volunteers In The Parks website at <www.nps.gov/archive/volunteer/air.htm>

[7] "51st Annual Bat Flight Breakfast" National Park Service, <www.nps.gov/cave/planyourvisit/50th_bat_flight_breakfast_2007.htm>

[8] Brandi, John. "The Guadalupes: A Closer Look." Portfolio of poetry and art, 1978. Reproduced with the author's permission.

[9] Bausch, Robert. Personal communication, 2008.

[10] Kerbo, Ron. Personal communication, 2008.

[11] Nymeyer and Halliday, *Carlsbad Caverns: The Early Years*, Foreword by Ron Kerbo, *iv*.

[12] Metropolitan Museum of Art/Heilbrunn Timeline of Art History. 2009, <www.metmuseum.org/toah/hd/dagu/hd_dagu.htm>

[13] Shlaer, Robert. Personal communication, 2009.

[14] Shlaer, Robert. *Sights Once Seen: Daguerreotyping Fremont's Last Expedition through the Rockies*. Santa Fe: Museum of New Mexico Press, 2000.

Chapter Seven

[1] Howes, *To Photograph Darkness,* 264-265.

[2] Bosted, Peter and Ann. Personal communication, 2008.

[3] Bunnell, Dave. Personal communication, 2008.

[4] Boyd, Tim. Personal communication, 2008.

[5] Burton, Chuck. Personal communication, 2008.

[6] Glover, Kevin. Personal communication, 2008.

[7] Adkins, Anni. Online source, <http://www.anniadkins.com/anni_adkins_bio.htm>

[8] Hoover, Joe. Online source, <http://joehoover.com/1tinted_gallery.htm>

[9] Jones, Peter. Personal communication, 2008.

[10] Queen, Dr. Michael. Personal communication, 2008.

[11] Pate, Dale. Personal communication, 2008.

[12] Woods, John. Online source, http://home.att.net/~jcwoods/pages/page2.html

Chapter Eight

[1] Payne, William. "I'd Rather be Cavin.'" Original song, music and lyrics written in 1979.

[2] Shrewsbury, Carolina, "On the Road to the Eye of the Beholder" Essay, 1997. <http://hawaiiflow.com/SpeleoArt/road.html>

[3] Davila, Jess. "Bringing Stone to Life." Online source, <http://www.jessdavila.com/>

[4] Davila, Jess. Personal communication, 2008.

[5] Elmore, Steve. Artist's statement, 2008.

[6] Widmer, Urs. *Lechuguilla, Jewel of the Undergound.* Basel, Switzerland: Speleo Projects Caving Publications International, 1991.

[7] Heslop, Linda, *The Art of Caving.* Saint Louis: Cave Books, 1996, 11.

[8] Kaleta, Elzbieta. "Artist Information," 2008.

[9] Komensky, Andy. Personal communication, 2008.

[10] Prather-Stroud, Wren. Artist's statement, 2008.

Index

Author

Lois Manno has two previously published books: *Cody Coyote Cooks* (Tricycle Press, a Division of Tenspeed Books, 1996) and *Silly Celebrations* (Aladdin Paperbacks, a Division of Simon & Shuster, 1998). Her illustrations have appeared in dozens of other books and periodicals. As a caver with 30 years of experience, Lois has worked on several notable projects, including a NOVA program about Carlsbad Caverns.

She brings a uniquely personal point of view to writing a book such as this, since Lois herself is one of the fine artists who has fallen under the spell of Carlsbad Caverns. She has

coordinated several fine art exhibits focusing on speleological art over the years, and was a founding member of the National Speleological Society's Fine Arts Salon. Lois has a Bachelor's Degree in Fine Art and has lectured on both art and caving. She is a Fellow of the Cave Research Foundation and is also a Fellow of the National Speleological Society. As Director of the Cavern Arts Project, she curated and exhibit of the park's photography and fine art collection, and helped plan and develop the new permanent gallery in the Carlsbad Caverns visitor center.